IMAGES
of America
MARITIME
SEATTLE

Dedication

Joe D. Williamson
March 28, 1909–February 26, 1994

This book is dedicated to the memory of Joe D. Williamson, photographer and historian. Joe was the man probably the most responsible for the creation of the Puget Sound Maritime Historical Society, along with the original five co-founders when the Society was formed in 1948. He was the first President of the Society and served in that capacity for three terms.

Next to his family, Joe's passion was photography. The documentation of maritime history, through his photos, was his life work. He was an avid photographer—opening his own photo shop on the Seattle waterfront in 1937. His Marine Salon, located on the upper level of the viaduct connecting Colman Dock with Grand Trunk Dock, became a haven for "boat nuts," with Joe photographing anything that would float.

Joe closed his shop in 1962 and moved to a waterfront home on Bainbridge Island, where he continued with photography until he retired in 1980.

His vast collection of photographs was purchased in 1980 by the Puget Sound Maritime Historical Society and is now housed at the Museum of History and Industry Library. This lifetime work of over 35,000 photos and negatives is a tribute to Joe Williamson's dedication to the preservation of northwest maritime history—a love and dedication that will serve generations to come. The majority of the photos in this book were selected from the Williamson Collection.

As noted northwest historian and author Lucile McDonald once said: "More than a photographer, Joe Williamson has been a focal point of recorded Puget Sound history for a half century, and he will one day be the equal of the famous logging photographer Darius Kinsey."

IMAGES
of America

MARITIME
SEATTLE

Puget Sound Maritime Historical Society

ARCADIA

Published by Arcadia Publishing
Charleston SC, Chicago IL, Portsmouth NH, San Francisco CA

Printed in the United States of America

Library of Congress Catalog Card Number: 2002105075

For all general information contact Arcadia Publishing at:
Telephone 843-853-2070
Fax 843-853-0044
E-Mail sales@arcadiapublishing.com

For customer service and orders:
Toll-Free 1-888-313-2665

Visit us on the Internet at www.arcadiapublishing.com

Puget Sound Maritime Historical Society Photographs available from this book.
The Society has several fine collections of maritime historical photographs relating to the Pacific Northwest, including the Joe Williamson Maritime Photographic Collection which consists of over 35,000 negatives and prints pertaining to Pacific Northwest nautical scenes. These historic photographs, like the ones noted in this book, are available for a fee. Please write or email the Curator of Photographs, Puget Sound Maritime Historical Society Library, 2700 24th Ave. East Seattle,WA 98112-2099; (206) 324-1126; or http://www.pugetmaritime.org

(*Cover photo*) Canada's Grand Trunk Pacific Railway built the Grand Trunk Pacific Dock and offered a ferry service between Seattle and Canada. It was the largest wood pier on the west coast at the time, measuring 600 feet on the pier with a 130-foot tower. This photo was taken around 1912, and shows the Smith Tower's steel construction in the background. The Smith Tower was the fourth tallest building in the world, and the tallest outside of New York at the time it was built. It remained the tallest in Seattle until 1969. The steamship to the left of the tower and dock is *Yukon*, formerly H.F. Alexander's old *M.F. Plant*. A notorious hoodoo ship on the Pacific Coast, she finished her ill-fated career on June 18, 1913, when she struck a reef on Sannak Island on her return voyage to Seattle. The Grand Trunk Pacific Dock building burned on July 30, 1914 (see photo on page 74), in a spectacular fire, but was rebuilt, without the tower, soon after. The dock was demolished in 1964 for the current Colman Dock. The back cover, continuing from the front, shows the Seattle Fire Department's fireboat station with the twin-stack fireboat *Duwamish*. (Courtesy of PSMHS/Williamson collection, Neg. No. 5011-25)

CONTENTS

ACKNOWLEDGMENTS

When the idea for this book was formulated, a Book Committee of the Puget Sound Maritime Historical Society's Editorial Board was formed. It would have been impossible to have accomplished all that has been done without the dedication and cooperation of this very special team. I wish to thank Ron Burke, Suzanne Berg, Jean Burrowes, Elizabeth Engle, Harold Huycke, Jim Lovejoy, Michael Mjelde, Scott Rohrer, Mark Shorey, and Hal Will for their generous and unwavering assistance. And thanks to Shirley Will and Nan White for the refreshments that helped keep us going on Saturday mornings.

The Society is especially indebted to Bill Lerch, Past President of the Puget Sound Maritime Historical Society (PSMHS) and Committee member, whose idea it was to launch this book project. Bill spent much time and effort securing the initial grant from King County Landmarks and Heritage Foundation, and we are grateful for his editorial writings and his energetic and enthusiastic assistance throughout the project. Others who contributed were:

Jim Cole, artist and past PSMHS President, whose historical perspective on Northwest fishing vessels added a unique viewpoint through his drawings and paintings. Hewitt Jackson, noted maritime historian and artist. Kathy Oman and Lane Gwinn, our photo editors, whose distinctive knowledge of computer photo graphics and layout design has been of immense help.

Paul Dorpat, noted Seattle historian, for his introductory remarks.

Phyllis and Jim Kelly, Curators of Photographs, PSMHS; Howard Giske, Curator of Photography; and Carolyn Marr, Librarian with the Museum of History & Industry (MOHAI). These PSMHS and MOHAI personnel were extremely helpful in securing and scanning the photos from their collections, the source of many of the photos in this book. The PSMHS Board of Governors, for their support and assistance.

The following institutions have given generous assistance: the University of Washington Special Collections Archives, and the Washington State Historical Society.

Sarah Wassell, Acquisitions Editor at Arcadia Publishing, for all the fabulous guidance and for being there when we needed support and help.

A special thank you to the King County Landmarks and Heritage Commission, Hotel/Motel Tax Revenues, whose financial grant made possible the publication of this book. Without their aid in funding for the photo acquisitions, scanning, and start-up phases, we would not have been able to publish *Maritime Seattle*. A special appreciation to Holly Taylor, Heritage Program Coordinator, for her guidance and support during the project. Thank you, King County Landmarks and Heritage Commission. We couldn't have done it without you.

Gary M. White, Editor and Book Committee Chairman

King County
Landmarks & Heritage Commission
Hotel/Motel Tax Fund

Membership in The Puget Sound Maritime Historical Society
The Puget Sound Maritime Historical Society draws its membership from throughout the world and is open to anyone interested in maritime history. Visit our web site to learn more about us and how you can become a member at http://www.pugetmaritime.org. Inquiries may also be addressed to: The Puget Sound Maritime Historical Society, P.O. Box 9731, Seattle, WA 98109. We welcome your interest.

INTRODUCTION

Action we wanted and action we got—action mixed with history—a novel combination."
Jim Gibbs, the author of that spirited recollection, was one of the "gang of five" who, with
clam chowder, toasted the founding of the Puget Sound Maritime Historical Society (PSMHS)
in a cozy little meeting above Ivar's Acres of Clams on April Fools' Day, 1948. Long ago Gibbs
moved to his own Coast Guard approved "Cleft In The Rock" lighthouse on the Oregon Coast.
Tom Sandry is now the last surviving member of the five still living beside Puget Sound. Passed
are Austen Hemion, Bob Leithead (most recently), and Joe Williamson, the Society's first
president and both the dedicatee and major source of photos used in this, the Society's first
book.

A half-century later we know well that those "April Fools" of 1948 turned out to be wise
ones. In nearly as many ways as there are members, the PSMHS continues to fulfill its mission
of collecting, preserving, and interpreting Puget Sound marine history. For most, this means
ships. This book is a fine example of the Society's and its founders' love for ships—all kinds of
ships—and the mariners who built and worked them. On practically any maritime subject there
will be at least one member who knows something about it and probably a lot. As a society of
experts it is "self correcting." Share a story at a Society meeting or banquet, write a scholarly
article for *The Sea Chest*, or merely make some claim in the PSMHS Newsletter and every
member will hear or read it like an editor. This is particularly comforting for landlubber
historians like myself who need help. And there is room in the Society for late-coming
landlubbers.

From its first year the Society has awarded lifetime memberships to persons of maritime
achievement. Captain E.B. Coffin of the crack Mosquito Fleet steamer *Tacoma* got it first in
1948 at the annual Society banquet. Capt. Howell Parker of the *Virginia V* received it the
following year. The list of honorees has grown over the years to include a great variety of people
who have contributed to the preservation of maritime history, each in his or her own way.

From the beginning it seems that the Society proceeded in all the right directions. Women,
three of them, were included among its 34 charter members. In its second year it staged an
exhibit at the local boat show, and soon after, with the help of member Vivian Smith, the
Society set up a small waterfront museum in a room fittingly next door to the offices of the
Marine Digest, the region's primary maritime reporter.

Many of the earliest artifacts collected by the Society were the rewards of "moonlight
requisitioning," with intrepid members salvaging or rescuing abandoned history under the cover
of dark. After it opened in the early 1950s the Museum of History and Industry and the PSMHS
nurtured a friendship that added a Maritime Wing to MOHAI in 1958–59. The Society's
collection now features more than two thousand marine-related artifacts as well as several
hundred more that are on long term loan. Add the Puget Sound Maritime Research Library
with its more than 35,000 marine photographs, more than 5,000 marine-related books, and
scores of individual archival collections and you almost get the picture of an organization that
has done well at mixing action with history. However, we must add *The Sea Chest*.

Since first published in the fall of 1967, *The Sea Chest* has been the soul of the Society or,
better, its cement. By the reckoning of Hal Will, who was on the publication's first editorial
board, and effectively its first editor, it is the quarterly mailing of 780-plus journals that "hold
the members from far and wide." As Will remembers it, Wilbur D. Thompson first urged that a
regularly published journal fulfill the often-scholarly interests of the Society's bulky newsletter.

The first issues were collated at the home of William O. Thorniley who had the fancy fonts and who designed the first cover. Thorniley was the well-loved PR man for the Black Ball Line and the wit behind the building and marketing of the "world's first streamlined ferry," *Kalakala*. Hal Will was editor of *The Sea Chest* for over nine years until relieved by Ed Shields for two years when Will served as Society President. Cofounder Austen Hemion followed as editor for twelve years, then Mike Mjelde for another ten. Ron Burke currently edits the quarterly.

Probably the best action and gratuitous commotion has been the races started by the Society in its first year, 1948, when the last of our Mosquito Fleet, the *Sightseer* and the *Virginia V*, throttled along the Central Waterfront. In the years following, sternwheeler and most often tug boat races have stirred the members as well as the general public.

Writing the Society's history for its 1973 Silver Anniversary, PSMHS member, the late Lucile McDonald noted the enduring attraction of what she called "the romantic days of shipping on Puget Sound." Now already four years following its golden anniversary the experts and enthusiasts of the PSMHS continue to pursue both the pioneer and contemporary romance of this protected and extraordinarily temperate inland sea. Its early mariners called Puget Sound our "Mediterranean of the Pacific." With the publishing of *Maritime Seattle* the Society again shows us that while cherishing the past of these waterways it can also stir them. Cofounder Jim Gibb's formula persists: "Action mixed with history—a novel combination."

Paul Dorpat

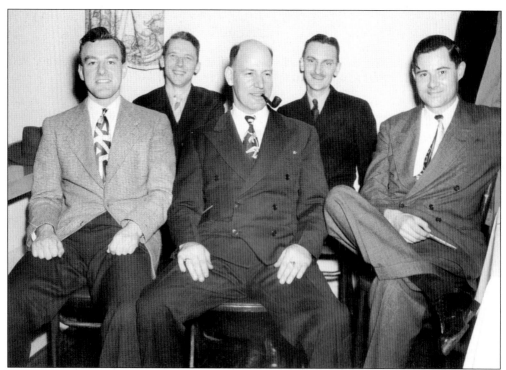

Pictured here, from left to right, are the original five founders of Puget Sound Maritime Historical Society: James A. Gibbs, Thomas E. Sandry, Joe D. Williamson, Robert C. Leithead, and Austen Hemion. (Courtesy of PSMHS photo collection)

One

From Forests to Piers, Mudflats to Commerce:

Frontier Seattle

Lieutenant Charles Wilkes, Commander of the first United States Naval Exploring Expedition, brought four ships, *Vincennes*, *Peacock*, *Porpoise*, and *Relief*, with scientists, naturalists and botanists to Puget Sound in 1841. In 1846, "joint ownership" between the United States and Great Britain of Puget Sound and the land north of the Columbia River was abolished and the boundary was set at the 49th parallel. The census of 1850 logged 1,049 white or non-Native Americans living north of the Columbia River, but only one small settlement was starting up near Tumwater-Olympia.

In an early morning chilling drizzle on November 13, 1851, 10 adults and 12 children landed at Alki Beach, what is now West Seattle. The "Denny Party" had been brought up from Portland, Oregon, on the schooner *Exact* to climax a grueling seven months travel that had started in Illinois. Others soon followed and staked their claims across the bay alongside those of Arthur Denny, Carson Boren, and William Bell. In 1853, Henry Yesler opened the first steam sawmill at the foot of a steep hill towards the southern side of the settlement. He skidded logs down to the mill and "Skid Road" has become Yesler Way.

Troubles with the Indians became tumultuous. The 200 or so settlers grew fearful and summoned the U.S. Navy to come for their protection. On January 25th, 1856, the Indians were

The *Exact*, Seattle's most historic ship, carried Seattle's first settlers. The schooner dropped anchor off Alki Point on November 13, 1851, and the Denny party of 22 persons went ashore. In the Chinook jargon, Alki means "Bye and Bye." (Courtesy of the artist Hewitt Jackson)

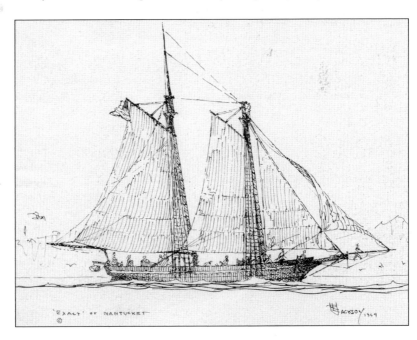

bombarded with ball, shell, and grapeshot howitzer fire from the sloop-of-war *Decatur*. The cannon fire kept the Indians at bay, but in retreating they destroyed nearly every building in King County that was beyond the protective fire from *Decatur*. The community remained armed and tense through 1860 with aid from the Army and Navy as they struggled to rebuild their community.

Development of the waterfront continued with thousands of trees cut and driven into the sea bed to make pilings to support the piers, buildings, and railroad tracks forming the waterfront. Charles Plummer built a long wharf across the mudflats fitted with an open flume to supply fresh water to the ships that tied up to his pier. He later added narrow gauge train tracks to supply ships with coal from the mines east of Lake Washington.

The 1860 census listed King County's population at 303, with 179 men over 21 years of age. Telegraph lines reached Seattle from San Francisco in 1864. Congress granted two townships for a territorial university in 1854. Seattle was finally chosen as the site for the University of Washington by the territory legislators in 1861; classes started November 4th of that year. Eleven young women, the first of the "Mercer Girls," arrived by ship via Panama and San Francisco in 1864. Of the one hundred passengers to sail around Cape Horn bound for Seattle in 1866, 46 were unmarried women or widows; the rest were families to complete the migration of Mercer Girls. Seattle was granted a city charter in 1869 and thus began two decades of strife and tribulation as the young city struggled with laws for development and control of its resources, water supply, sewage, and energy.

By 1870, the population had grown to merely 1,107 people. Speculation and anticipation over the Northern Pacific Railroad's plans to terminate at Puget Sound caused real estate values to soar; Seattle became a boomtown. In 1874, Tacoma was chosen instead of Seattle. Shock and anguish turned to action: Seattle decided to build its own railway across Snoqualmie Pass to Walla Walla, a distance of approximately 260 miles, using their own labor. The volunteers actually laid 12 miles of track from May to October 1874, before running out of steam. Three years passed and the decision was made to extend the line only to the coalfields in Renton.

Coal was discovered in 1853. The first deliveries to Elliott Bay were in sacks via small barges floated down the Black and Duwamish rivers. During the 1870s coal was transported to Elliott Bay by barges and small rail cars. By 1878, the railroad had been extended to Newcastle on Lake Washington and out onto a long wharf on Elliott Bay where four ships could be loaded at one time. Four engines and 50 cars moved 400 to 800 tons a day, making the Seattle and Walla Walla railroad one of the most lucrative railroad ventures in the Territory. Seattle had become a major port and worthy of a full transcontinental railroad terminus.

By 1880, the population had risen to 3,533 persons as the city grew and rebuilt itself after its first major fire (July 26, 1879). A shipyard, built near Yesler's Mill, was constructing schooners and small steamers, sea-borne commerce was expanding with the start of the "Mosquito Fleet," the flotilla of small steamers that plied the Sound and carried goods, people, news, and gossip to the many shoreside communities that had no other means of transportation or communication.

On June 6, 1889, an exploding glue pot in a carpenter shop started the Great Fire. It burned furiously all day and consumed buildings, piers, warehouses, and trestles. Aid came to Seattle from all over Puget Sound and the nation. Mayor Moran and nearly 600 business leaders unanimously agreed to rebuild Seattle bigger, better, brighter, and with *NO* wooden buildings. Thousands of people were attracted to Seattle and King County during this time of rebuilding. Within two years, Seattle was up and flourishing.

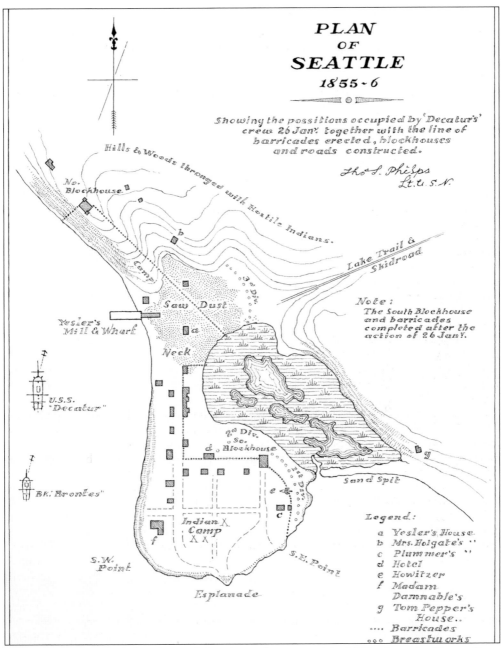

PLAN
OF
SEATTLE
1855-6

*Showing the possitions occupied by 'Decatur's'
crew 26 Jan?. together with the line of
barricades erected, blockhouses
and roads constructed.*

Thos S. Phelps
Lt. U. S. N.

Hills & Woods thronged with Hostile Indians.

No.
Blockhouse

Lake Trail &
Skidroad

Camp

b

3d Div.

Saw Dust

Note:
*The South Blockhouse
and barricades
completed after the
action of 26 Jan?.*

Yesler's
Mill & Wharf

a

Neck

U.S.S.
"Decatur"

2.d Div.
So.
d. Blockhouse

g

Sand Spit

Bk. "Brontes"

e

c

Indian
Camp

S.W.
Point

S.E. Point

Legend:
a Yesler's House.
b Mrs. Holgate's "
c Plummer's "
d Hotel
e Howitzer
f Madam
 Damnable's
g Tom Pepper's
 House..
.... Barricades
ooo Breastworks

Esplanade

These are the original shorelines of Seattle as they existed in 1852 when the Denny Party moved across the bay from Alki Point. They chose to make their permanent settlement on the low bank peninsula that was connected to hills and steep bluffs north, south, and east. The map indicates the buildings and roads that existed a few years later, together with the defensive works erected during the Indian uprisings. The dotted outlines show beginnings of the present day street system. The north-south route from "SW Point" to "The Neck" would become First Avenue South; the east-west route north of "Indian Camp" would become South Jackson Street. Dredge spoils eventually filled the salt marsh and tide flats to the south, with final completion in 1902. (Courtesy of the artist, Hewitt Jackson)

Looking north across the Elliott Bay shoreline in about 1880, this photo appears to have been taken from the railroad dock at King Street where deepwater ships could load coal from mines in the hills above the south end of Lake Washington. The large hip-roofed building on the right is the Talbot Coal Dock, one of several which served the local coal market. An unidentified three-mast barkentine lies along the south face of Yesler's Wharf. Signs on some of the pier sheds reveal that they are "commission houses," which act as wholesale brokers in distributing produce from local farmers. Careful examination of the shoreline beyond reveals the log bulkhead that once bordered Front Street (later First Avenue). On the horizon at right-center is the first building of the original University of Washington. (Courtesy of MSCUA, Univ. of Washington Hester Collection No. 10059)

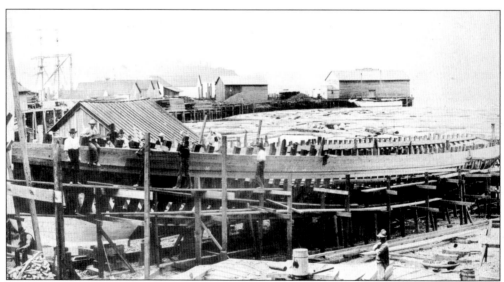

The pioneer steamer *George E. Starr* is shown being planked in the Seattle yard of V.F.T. Mitchell in 1879. She was a sidewheeler with a walking beam engine and was considered to be a fast boat. After 10 years on Puget Sound routes she was tried on the Columbia River Ilwaco-Astoria run but after a few months was back on the Sound. During the Yukon gold rush she made runs to Skagway, Alaska, but mostly operated between Seattle, Tacoma, Port Townsend, and Vancouver. She was the last large sidewheeler on Puget Sound when retired in 1911. Many of the well-known local steamboat captains served aboard her. (Courtesy of MOHAI photo collection, Neg. No. 970.384)

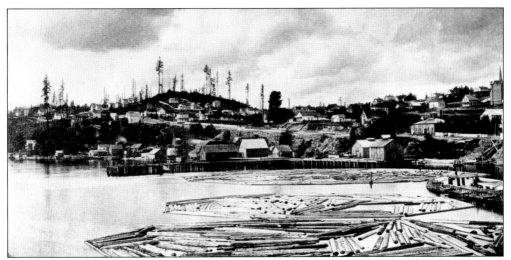

This is a photo of Elliott Bay taken by the Peterson Brothers in 1878. The view is from Yesler's Wharf looking north toward Denny Hill. The log booms are intended for Yesler's Mill, which, at the time, was operating under lease to J.M. Colman. The hulk with decks awash is the bark *Windward* that was wrecked at Whidbey Island three years earlier. Colman bought the wreck, salvaged what he could, and put the hull in place as a breakwater offshore of his property on Front Street (later First Avenue). This established his "riparian rights" to what would become private property after statehood in 1889. The remains of *Windward* are now buried under the parking lot behind the Colman Building, diagonally across the corner of Columbia Street and Western Avenue. (Courtesy of MSCUA, Univ. of Washington, CUR 916 Asahel Curtis Photo Company Collection)

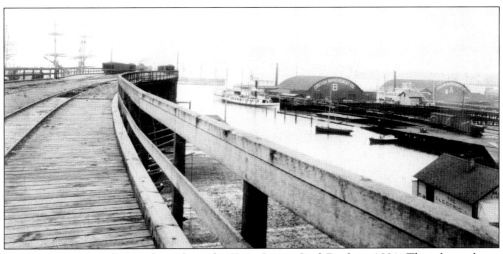

Frank La Roche took this photo from the King Street Coal Dock in 1891. This photo shows three steamers at the Oregon Improvement Docks: in the center is the fast little sternwheeler *Greyhound*, and behind her the elegant sidewheeler *T.J. Potter*, and on the right another sternwheeler, *Emma Hayward*. At this time *T.J. Potter* and *Greyhound* were running south to Tacoma, and *Emma Hayward* was serving the city of Bellingham in the north. *T.J. Potter* was considered one of the fastest steamers on the Sound, having set a record for her Tacoma-to-Seattle route the year before at 1 hour 20 minutes, or about 20 miles per hour over the 28 mile distance. (Courtesy of Mark Shorey)

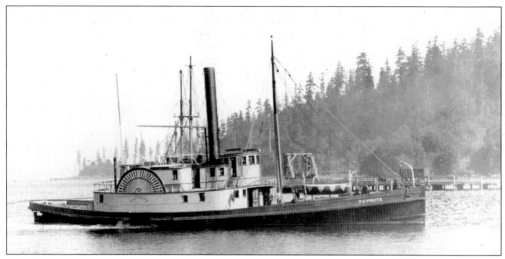

The sidewheel steam tug *Favorite* was typical of the wooden-hulled tugs on Puget Sound following the Civil War. Built at Utsalady, Camano Island, in 1868–1869, for service with the mill located there, the 132-foot vessel towed sailing ships and log booms for five years and then became a mail boat for two years. Thereafter, she saw service as a tug with several of the lumber mills on Puget Sound, and in the mid-1890s, the Port Blakely Mill purchased her and used her as a combination tug/passenger boat, transporting people at times between Bainbridge Island and Seattle. *Favorite* remained in service until 1913 and was dismantled at Seattle in 1920. (Courtesy of PSMHS, Neg. No. 952)

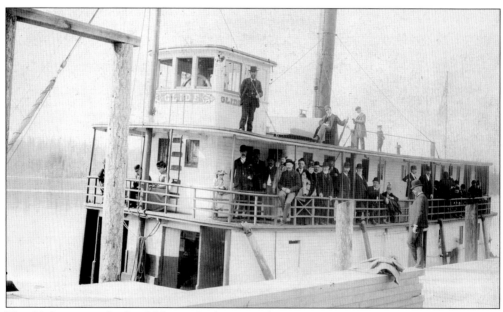

The 80-foot sternwheeler *Glide* was built in Seattle in May of 1883 to serve the small towns that had developed along the nearby rivers supplying Seattle with produce and other goods. She is a good example of the many small vessels that tied the communities together throughout the Puget Sound area. *Glide* survived until she caught fire on a trip between Everett and Seattle in July of 1902. Note the dapper dude on the top deck with the sunglasses and umbrella. The lack of any railing is definitely not up to today's safety code. (Courtesy of Mark Shorey)

14

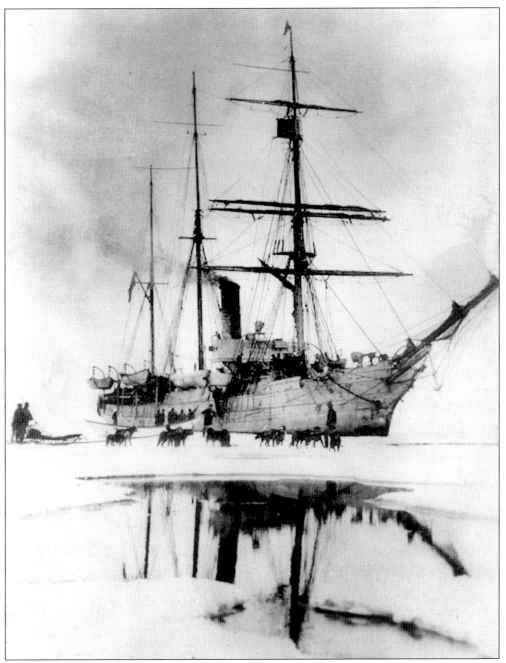

The Revenue Cutter *Bear* was launched at Glasgow, Scotland, in 1874 with a hull intended for work in the ice. The U.S. Navy acquired her for Arctic voyages, and in 1885 she was assigned to the Revenue Marine. For the next 41 years *Bear* patrolled the Bering Sea as far as Point Barrow with frequent visits to Seattle. The crews and captains performed search and rescue missions, transported officials, administered justice, and provided medical assistance to the Eskimos. In her retirement years, *Bear* made two Antarctic voyages with Admiral Richard Byrd and served in the Northeast Greenland Patrol with the U.S. Coast Guard in World War II. (Courtesy of Coast Guard Museum Northwest, No. 78.13/1)

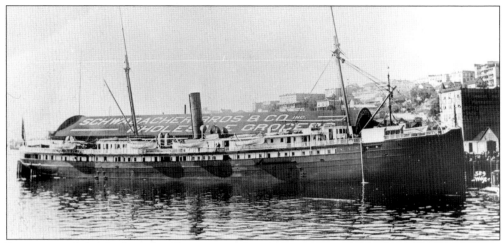

Passenger and freight from San Francisco to Seattle was common in the early 1900s. Here we see the *S.S. San Blas* unloading cargo at the Schwabacher Bros. & Co., wholesale grocers in Seattle, and preparing for a return trip to her homeport of San Francisco. The Seattle skyline can be seen in the background. *San Blas* was a steamship built in Chester, Pennsylvania, in 1882, with an overall length of 283 feet, beam 37 feet, and a depth of 21 feet. During the mid-1890s she served as an immigrant ship between Panama and San Francisco transporting immigrants to the U.S. The voyages lasted approximately three weeks. Later *San Blas* began trips between Seattle and San Francisco. (Courtesy of Mark Shorey)

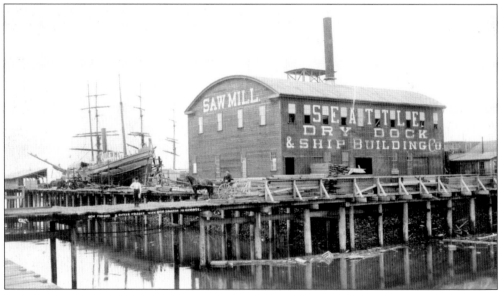

In 1889, Moran Bros. Co. was the principle stockholder of the Seattle Dry Dock and Shipbuilding Company. This view, after the Great Fire, shows three vessels, two of which played significant roles in local history. Under construction is the hull of Seattle's first fireboat, *Snoqualmie*. Behind her can be seen the tall stacks, deckhouse, and two masts of the revenue cutter *Oliver Wolcott*. She was schooner-rigged and patrolled the Pacific Coast from the Mexican border to the Bering Sea from 1873 to 1897. The three square-rigged masts are the ship *Spartan*, which is moored across the face of the wharf. (Courtesy of MSCUSA, University of Washington, Neg. No. 6973)

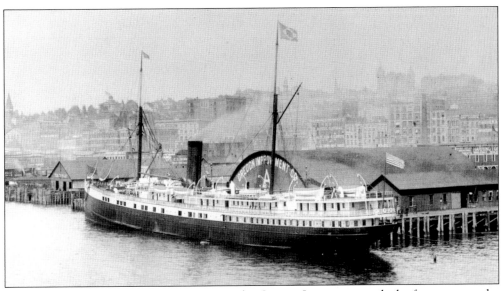

The fine steamer *City of Puebla* is shown at the Oregon Improvement dock after a run up the coast from San Francisco in the early 1890s. The Oregon Improvement Company owned a number of the ships that ran on the coast and controlled railroads, sawmills, and most of the coal mines in the northwest, but they let the Pacific Coast Steamship Company operate their ships. That is why in some photos you see Pacific Coast Steamship Company-flagged steamers tied up to the two Oregon Improvement Company docks. This changed in the financial panic of 1893 when the latter company went bankrupt and Pacific Coast Steamship took over all of their ships and ran them under their flag. William Cramp built *City of Puebla* in Philadelphia in 1881. (Courtesy of Mark Shorey)

The new steamship *Senator* has just pulled into her dock at Seattle during the summer of 1898 at the height of the Alaska Gold Rush. She was the first new ship to be built for the Pacific Coast Steamship Company by a West Coast shipbuilder, in this case the Union Iron Works at San Francisco. She was soon taken over by the U.S. Army as a troop transport during the Spanish-American War and was not returned to regular service until February 1900. *Senator* was later renamed *Admiral Fiske* during her tenure under the Admiral Line houseflag, and survived until the mid 1930s when she was scrapped in Japan. (Courtesy of Mark Shorey)

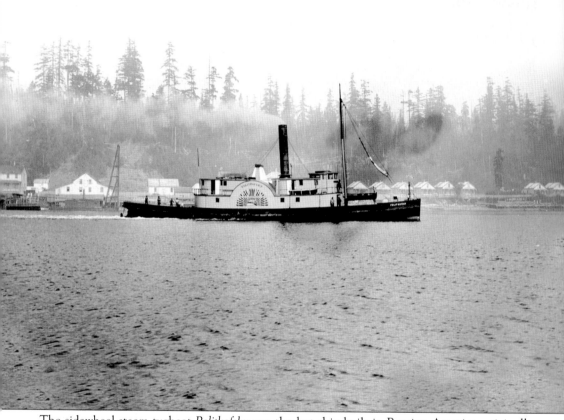

The sidewheel steam tugboat *Politkofsky* was the last ship built in Russian America, originally going in service three years before the U.S. purchased Alaska from Russia in 1867. The *Politkofsky* was purchased by the predecessors of the Alaska Commercial Company, and in 1869 Meigs and Gawley, owners of the Port Madison Mill, purchased and operated her as a combination tow/passenger boat on Puget Sound. In 1879 Dexter Horton Bank in Seattle, as part settlement of a loan, operated the Polly for four years and then sold her to William Renton of the Port Blakely Mill, who used her as a towing/freight boat. In 1897 *Politkofsky*'s new owners, the Yukon Trading Company, converted her into a coal barge, and she became part of the *Eliza Anderson* expedition trip to the mouth of the Yukon River at St. Michael in 1898. "Polly" was eventually abandoned. (Courtesy of PSMHS, Neg. No. 681-4)

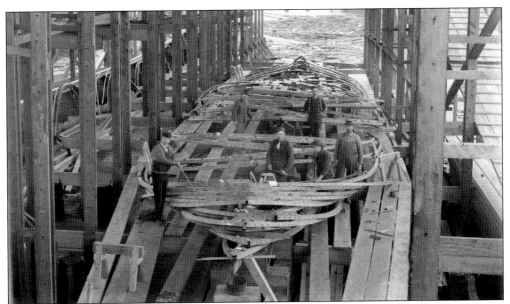

U.S.R.C.S. tug *Golden Gate* had the distinction of being the first steel vessel built on Puget Sound. Moran Bros. Company built her in 1897 for the U.S. Revenue Cutter Service to be used on San Francisco Bay. All of the frames are stacked in sequence from stem to stern ready to be raised and joined by fore-and-aft members. Note the mass of driftwood on the water beyond. (Courtesy of Hal Will)

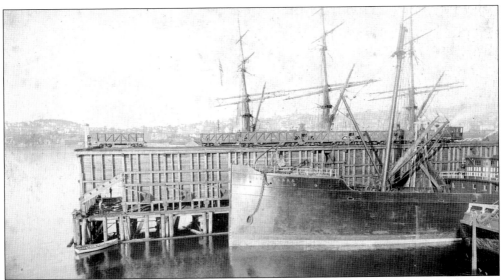

This early view was taken by Theodore Peiser and shows the steamship *Walla Walla* loading coal at the King Street coal dock. This photo was taken before the Seattle Fire as *Walla Walla* and her sistership, *Umatilla*, were rebuilt in 1888 as passenger-carrying ships. Photographs taken before the Seattle Fire on June 6, 1889, are rare as nearly all the city's photographers, Peiser included, lost their shops, photos, and negatives in the conflagration. Fortunately, this image survived and recorded Seattle's chief export of the time, coal. The railcars on the pier rattled and shook their way from Renton on a rail line that opened on February 5, 1878. The coal was moved from the mines around Renton to steam colliers and sailing ships. (Courtesy of Mark Shorey)

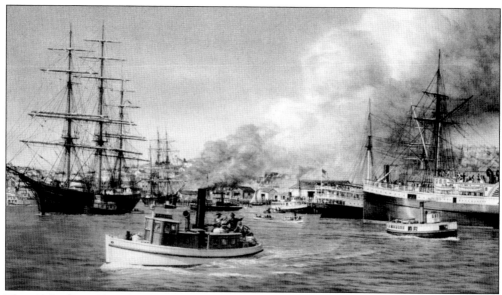

This is the Great Seattle Fire as illustrated by Mark Myers. On June 6, 1889, at 2:30 pm, a gluepot overheated in a woodworking shop at the southwest corner of Front and Madison, starting a fire that eventually consumed much of the commercial district of downtown Seattle in a matter of hours. Most of the area was wood construction, which burned rapidly, but stone and brick buildings were destroyed as well by the fierce heat fed by strong winds. (Courtesy of Kirsten Gallery, original watercolor by Mark Myers©)

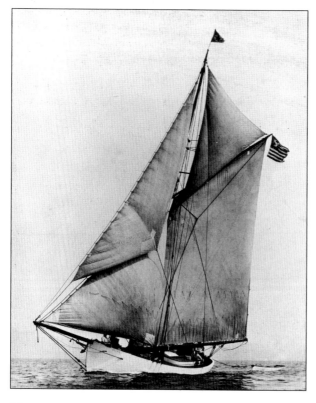

The beautiful cutter *Kelpie*, built by the Hall Brothers of Port Blakely in 1893, was owned by Fred E. Sander, son-in-law to Henry Hall. Sander served as commodore of the Seattle Yacht Club from 1893 to 1895. *Kelpie* was 38 feet in length and won many races in the 1890s, including the Labor Day race of the Elliott Bay Yacht Club in 1897. She was later converted to a gasoline screw fishing vessel and sold to Canadian owners and re-named *Kyrielle*. She was lost off the North Coast of Vancouver Island, B.C., in the early 1970s. (Courtesy of PSMHS photo collection, Neg. No. 4599)

Two

RESHAPING THE WATERWAYS:

FRESH WATER AND SALT WATER, 1890–1920

Seattle has been called the "Engineered City." Hills were lowered, tidal flats filled in, and canals and waterways were dug. By 1890, Seattle's population had swelled to 40,000; by 1900, the population numbered 80,761.

Six schemes for the construction of a canal from Lake Washington to Elliott Bay were advanced between 1876 and 1890. In 1885 25 Chinese laborers dug a three-quarter mile canal from Lake Union to Salmon Bay and installed a small wooden lock. A sluiceway was dug from Lake Washington to Lake Union to allow the transportation of logs, but it was too small for vessels. Logs could then be transported from Lake Washington to the salt water directly.

Finally after much political wrangling between local, state, and federal governments, Congress authorized the construction of the two locks in 1910, and King County was responsible for the dredging of the canals. The plan called for the lowering of Lake Washington nine feet to the level of Lake Union. The water level in Salmon Bay east of the locks would be raised a like amount. The Cedar River to the Southeast was diverted into Lake Washington so that there would be a continual supply of water to the canal system. The Lake Washington Ship Canal was finally opened for traffic from the salt water to Lake Washington and dedicated in 1917. Four bascule bridges, Ballard, Fremont, University, and later, Montlake were constructed over the canal. The two high level bridges came much later.

Major (later General) Hiram M. Chittenden of the U.S. Army Corp of Engineers supervised the design and construction of the canal and locks. In 1911 he became one of the three port commissioners when the Port of Seattle was established.

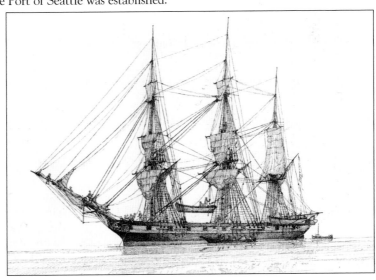

The sloop-of-war U.S.S. *Decatur* joined the Pacific Squadron in 1855. She was in Elliott Bay on January 26, 1856, to provide fire support for the Seattle pioneers defending against the Indian attack. (Courtesy of the artist Hewitt Jackson)

In 1887 the Northern Pacific Railway brought its first train across the mountains to Tacoma, bypassing Seattle to the chagrin of the city's leaders. The rival Great Northern Railway, built by James J. Hill, arrived in 1893 and established the first passenger depot at the foot of Columbia Street. The depot was relocated to the newly constructed King Street Station in 1905. Hill developed trade with the Orient by building two ships, *Minnesota* and *Dakota* and a great pier in Smith Cove, north of Elliott Bay, to service his transcontinental railway and insure cargo in both directions. He contracted with the Japan Steamship Company, and trade commenced in 1896. Soon trade increased, and the "silk trains" were speeding cargoes of raw silk to Eastern mills. Today the original Great Northern Docks in Smith Cove have been filled in and converted to industrial land.

The hodgepodge of piers farther south that had been destroyed or damaged by the great fire of 1889 were rebuilt all angled to the Northwest to provide easier access for the railroad. Railroad Avenue, built on pilings and paved with wooden planks, backed up the piers providing access for trains, wagons, and trucks. The downtown waterfront was a beehive of activity with the advent of the Alaskan Gold Rush of 1897 and 1898. Cargo and people, engaged in boisterous activity, made Seattle the "Gateway to Alaska."

As the Seattle waterfront was being reshaped physically, it was also undergoing a major increase in industrialization. Shipyards, foundries, and machine shops were created to build the ships and engines needed for the Alaskan adventure. This industrial base was further expanded during World War I. Over 40,000 workers were employed building wooden and steel ships in Seattle's 20 shipyards and allied industries at the peak of the war effort.

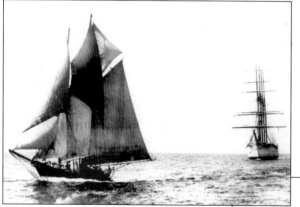

The schooner *Ela G* has a full load of halibut as she was photographed under tow as well as under full sail off Cape Flattery. Built in Seattle in 1896, she was lost off the coast of Vancouver Island in March 1905. The barkentine in the background also appears to be a towing prospect. (Courtesy of Harold Lokken)

In 1894 a fleet of 123 American sealing schooners sought the herd feeding off the Washington coast. These fur seals could be found 15 to 20 miles offshore while migrating north to the Pribilof Islands in the Bering Sea. Some vessels were based in Seattle but operated out of the Strait of Juan de Fuca, frequently having crews of Native American hunters from Neah Bay. These hunters worked from their own canoes, which were carried on board. Seals were shot or speared while in the water, a method known as "Pelagic Sealing." (Courtesy of the artist James A. Cole)

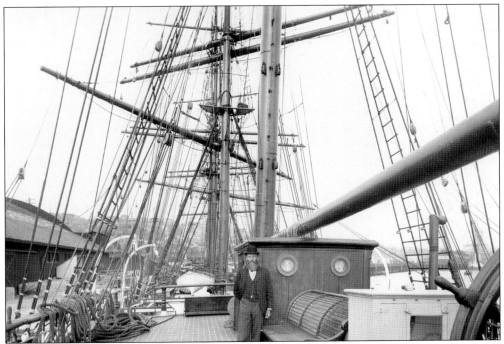

Wilhelm Hester was an immigrant German who came to Puget Sound in the 1890s and became one of the most productive photographers of ships and the waterfronts for more than two decades. He found his subjects, mostly sailing ships, in Tacoma, Seattle, and Port Blakely, and specialized in deck scenes, interiors, and the crews from far-flung ports. Here is the poop deck and shipmaster of the British, four-masted bark *Lucipara* on the Seattle waterfront at the turn of the century. (Courtesy of Harold Huycke, photo by Wm. Hester)

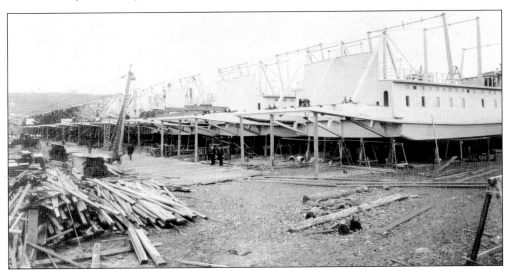

Moran Bros. Co. enjoyed lots of business from the Klondike Gold Rush. They built 12 sternwheel steamers 175 feet long by 35 feet wide for use on the Yukon River. These vessels were built to be used in shallow river water but had to be sturdy enough to make the ocean voyage to Alaska. They were all built together and started the trip north together May 26, 1898. There were mishaps along the way but most made it to St. Michael. (Courtesy of MOHAI, Neg. No. shs2356)

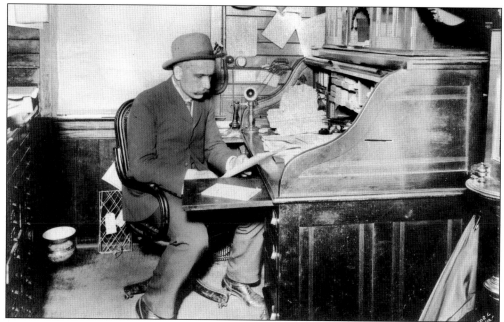

Pictured is Robert Moran in his shipyard office. He started the firm in 1882 and incorporated it as Moran Bros. Co. in 1889. He was mayor of Seattle at the time of the Great Seattle Fire in 1889. Moran was a "detail" man and carried the weight of the business on his shoulders, causing his health to suffer during construction of the battleship *Nebraska*. Doctors gave him six months to live after the big ship was launched, so he retired May 31, 1906, to Orcas Island in the San Juan Islands. He regained his health, built an estate, and lived to 86, dying in 1943. (Courtesy of MOHAI, Neg. No. shs1961)

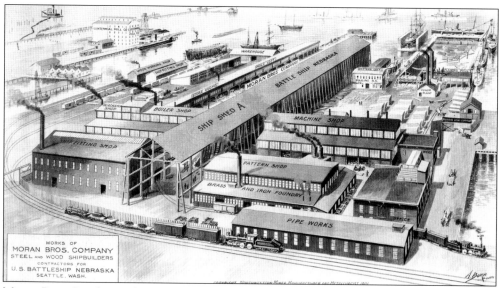

Moran Bros. Co. shipyard is pictured here looking west across Elliott Bay and tide flats toward West Seattle. This 1901 bird's eye view, created for the publication *Northwestern Miner, Manufacturer and Metallurgist*, identifies the function of the different buildings or areas. (Courtesy of Hal Will)

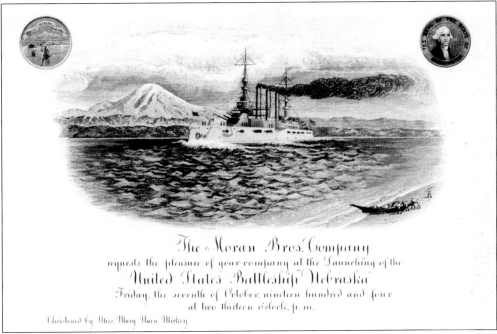

The Moran Bros. Company
requests the pleasure of your company at the Launching of the
United States Battleship Nebraska
Friday, the seventh of October, nineteen hundred and four
at two thirteen o'clock, p. m.

Christened by Miss Mary Nason Mickey

This is an invitation to the 1904 launching of the battleship *Nebraska*. The ship was completed and delivered to the Navy at the Bremerton Navy Yard June 1, 1907. It subsequently circled the globe as a unit of the Great White Fleet starting in July 1908 and ending in February 1909. (Courtesy of MOHAI photo collection, Neg. No. 970.384)

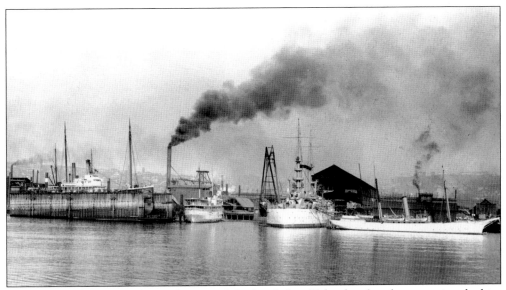

This view of the Moran shipyard captured the battleship *Nebraska* after she was painted white for her role as a member of the Great White Fleet and before her delivery to the Navy at Bremerton, June 1, 1907. The date was probably May 1907. *Nebraska*'s keel was laid July 4, 1902. The white ship to the right of *Nebraska* resembles the U.S. Revenue Cutter Service's *Oliver Wolcott*, which was retired in 1897 and sold to Joshua Green, who turned it over to the Pacific Steam Whaling Company. (Courtesy of PSMHS photo collection, Neg. No. 6727-22)

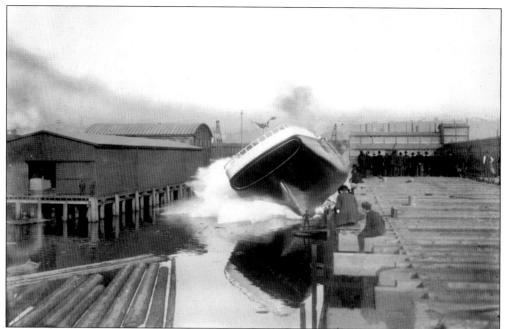

Pictured is the launching of the four-mast barkentine *James Johnson*, March 19, 1901, at Moran Bros. Company in Seattle. Built for Charles Nelson Company of San Francisco, she registered 1,149 tons and could carry 1.3 million gross board feet of lumber. In January 1923 she put into San Francisco leaking badly, 30 days out of Hilo bound for Port Angeles. She was ultimately burned for scrap in San Francisco about 1926. (Courtesy of Hal Will)

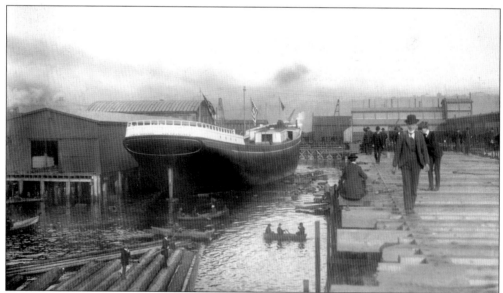

Immediately following the launch of *James Johnson*, spectators disperse and people in rowboats move in for a closer look. Note the photographer on the logs in the foreground has folded his tripod with the large glass plate camera mounted on it. We can be grateful for the tenacity of those early photographers in capturing scenes such as this with their cumbersome equipment. (Courtesy of Hall Will)

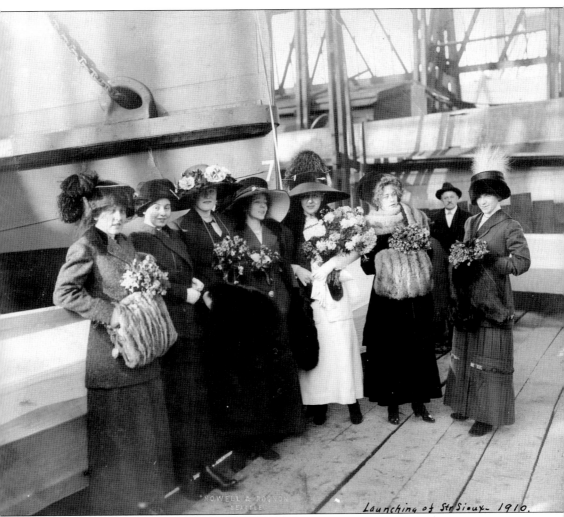

Launching of Str Sioux - 1910.

On December 31, 1910, the first steel steamer built on the West Coast for the Black Ball line, *Sioux*, was launched at the Moran shipyard (later known as Seattle Construction and Drydock Company Shipyard). The launching was not only an engineering success, but as seen in this photo of women dressed in their most elegant attire, a social success as well. The *Sioux* was placed in service the following year between Seattle, Irondale, and Port Townsend. (Courtesy of MOHAI photo collection Neg. No. 2347-21)

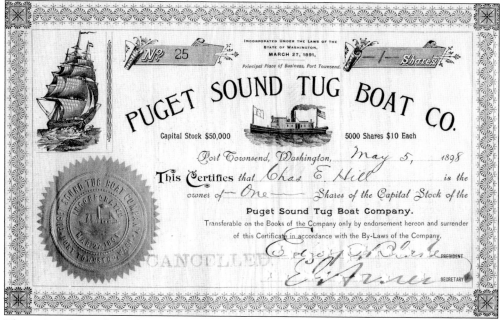

This is a stock certificate for Puget Sound Tug Boat Co., at one time operator of the largest fleet of ocean-going and harbor tugs on Puget Sound. This fleet serviced incoming and departing sailing ships engaged in deep sea and coastal trade. Their vessels also engaged in long distance tows to Alaska, British Columbia, Oregon, and California. Originally based in Port Townsend in 1891, headquarters were moved to Seattle in 1899 where they operated until after World War I. (Courtesy of Gary White)

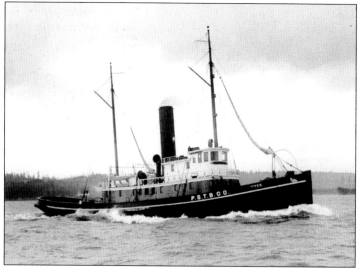

The ocean-going steam tug *Tyee*, one of the most strongly built and seaworthy wooden-hulled vessels ever built on Puget Sound, had a long career on the Pacific Coast. Constructed of seasoned fir for the Puget Mill in 1884 at Port Ludlow, the 141-foot vessel reached her zenith in 1891. That year she became the "queen" of the Puget Sound Tug Boat Co. fleet, a combination of towing vessels from four Puget Sound lumber mills formed to bring economic stability to the ocean-going tugboat industry on the Sound. For 34 years she towed sailing ships engaged in the lumber and coal trade to and from Cape Flattery as well as offshore towing. In 1918, with the decline of sailing ship activity, PSTB Co. sold her to Skinner & Eddy. After the war, Cary-Davis chartered her, and by the 1930s, she had the "Port of Bellingham" on her stern. (Courtesy of PSMHS, Neg. No. 2575-16)

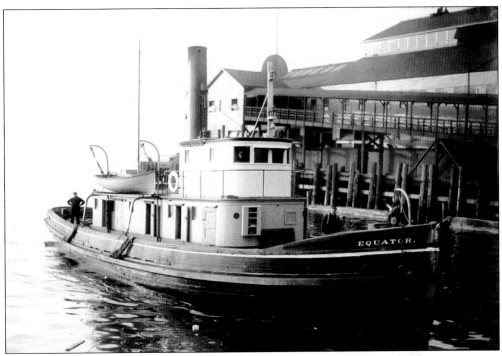

The 82-foot tug *Equator*, built at Benicia, California, in 1888, started out her long career as a two-masted schooner of wood construction. She is specially remembered as being the vessel that carried famed novelist Robert Louis Stevenson to the South Seas in 1889 and 1890. Converted to auxiliary steam power in 1893, she became an Arctic whaling fleet tender, operating out of San Francisco; after the turn of the century, she went through several changes of ownership until Cary-Davis of Seattle purchased her in 1915 for operation as a tug. She remained in service as a unit of the successor company, Puget Sound Tug & Barge Co. In 1957, when old and worn out, she was made into a breakwater. In the 1970s she was salvaged by the Everett Kiwanis Club, and now sits on blocks under cover in Everett. (Courtesy of PSMHS, Neg. No. 903-31)

The little tugboat *Christie R*, built by Ballard Marine Railway in 1914, and powered by a 45-HP semi-diesel engine, served as a unit of the Cary-Davis Company/Puget Sound Tug & Barge Company fleet for 30 years starting in 1918. Typical of the small tugs operating in and around Seattle, she commonly towed scows up various rivers to lumber mills, nudged them onto a gridiron, and then towed them down river once they

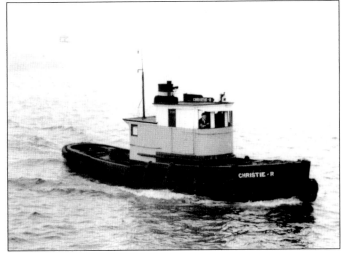

were loaded. *Christie R* spent her last days in Wrangell, Alaska, in the early 1970s. (Courtesy of PSMHS, Neg. No. 530)

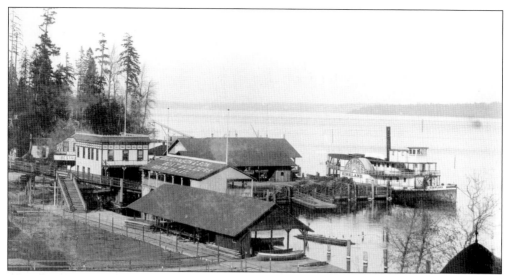

This 1892 view of the landing at Leschi Park shows the trim little side-wheeler *Kirkland*, a vessel built in 1888 to bring passengers across Lake Washington from Juanita, Houghton, and Kirkland. At Leschi, they could board the Yesler cable car that would deliver them to downtown Seattle. President Benjamin Harrison was once given a sightseeing ride on *Kirkland*. The cable railway trestle is visible on the left, and the buildings include John Johnson's Lake Washington Hotel and Restaurant and G.V. Johnson and Son's boathouse. (Courtesy of MSCUA, Univ. of Washington, Frank La Roche Photograph Collection, No. 146)

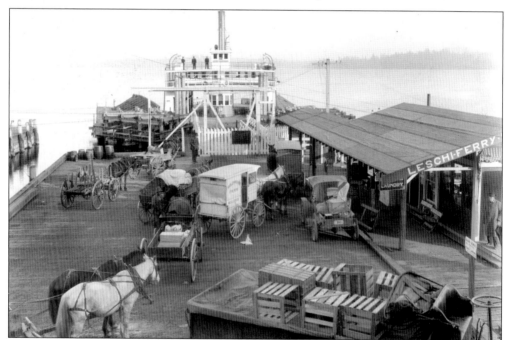

Long before the Lake Washington floating bridges were built, steamers and ferries departed from Leschi to East Seattle on Mercer Island, Meydenbauer Bay in Bellevue, and other points. Here an early steam-powered ferry prepares to receive horses and empty wagons that earlier in the day had brought produce into the city from Bellevue farms. (Courtesy of MOHAI, Neg. No. 83.10.10200)

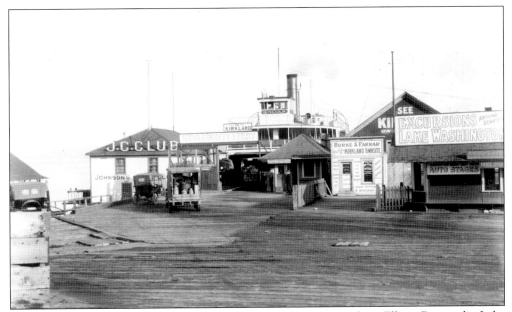

In the early 1900s, a cable car ran the length of Madison Street from Elliott Bay to the Lake Washington shore in Madison Park. From Madison Park one could take a King County ferry to Kirkland, or an Anderson steamboat to a number of rural landings scattered around the lakeshore, or for a pleasure excursion. (Courtesy of MOHAI, Neg. No. 83.10.10.197)

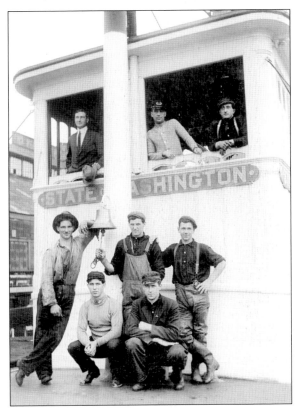

State of Washington was a sternwheeler built in Tacoma in 1889. She ran between Seattle and Bellingham, and, after 1905, on Hood Canal. A Stanley Steamer carried from Hoodsport to Seattle in 1906 may have been the first automobile transported across Puget Sound. (Courtesy of MOHAI, Seattle Historical Society, Neg. No. 17,080)

Here we see the officers of *Roanoke* preparing for another voyage to Nome, Alaska. She came to the Pacific Coast in the summer of 1898 to support the Yukon Gold Rush traffic. Many ships came from the East Coast and from around the world to carry the thousands of passengers and tons of freight that went north. *Roanoke* was one of the finest ships that a would-be prospector could travel on. She had been built in 1882 to run on the New York City to Norfolk run and was very finely finished with bird's eye maple and sandalwood interiors. She was a very large ship in her day, almost 300 feet long, and could carry over 500 passengers in very high style. (Courtesy of Mark Shorey)

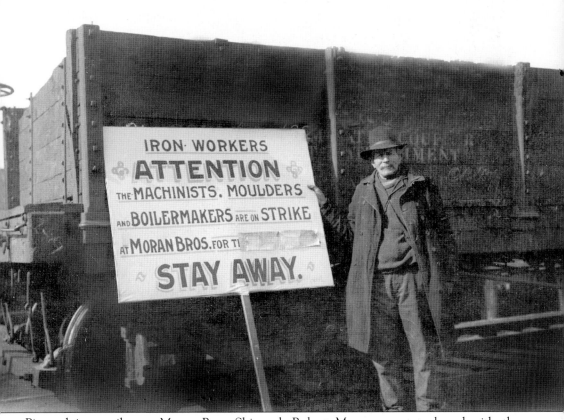

Pictured is a striker at Moran Bros. Shipyard. Robert Moran was not pleased with the ironworker's strike in 1903. He personally photographed this striker and his sign with a 5x7 glass plate camera and then made sure that everyone knew the identity of the photographer by signing and dating the negative with black ink. (Courtesy of Hal Will)

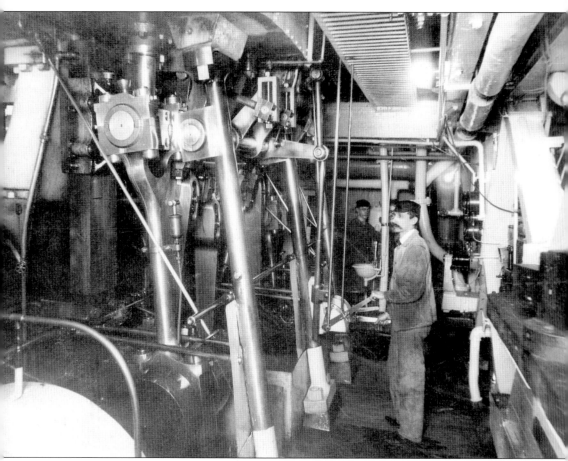

This 2,000 horsepower triple expansion steam engine powered the famous and speedy mosquito fleet steamer *Flyer* for 38 years of steady service. Unlike most other Puget Sound steamers, *Flyer*'s engine was reportedly virtually vibration free. It is believed that the engineer in this photo was Harry D. Collier, for 54 years a marine engineer in steamships of all sizes. (Courtesy of PSMHS photo collection, Neg. No. 974)

James M. Colman was a skilled steam engineer and millwright when he arrived at Port Madison in 1861. After 11 years of building, repairing, and owning other Puget Sound sawmills, he moved to Seattle to lease and manage Henry Yesler's mill. When a railroad was needed to haul coal from Renton to the coal dock at King Street, he volunteered to supervise construction and partially finance the effort. With California partners, he participated in other sawmills as well as facilitating the building of a lumber schooner and steam tug, both named *J.M. Colman*. He and his two sons built four steam yachts and developed the Colman Block and mosquito fleet dock on the Seattle waterfront. Colman Dock is now the terminal for Washington State Ferries. (Courtesy of Pierce Colman family)

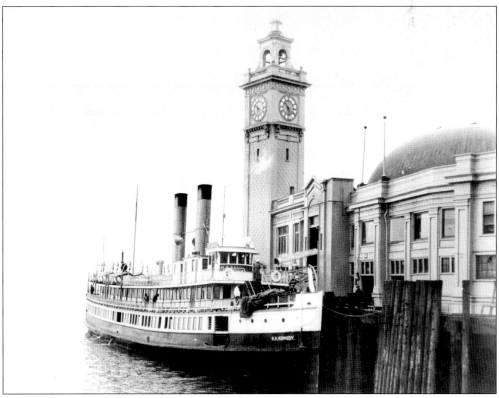

H.B. Kennedy was a familiar sight in 1910 as she lay alongside Colman dock. She was later completely rebuilt as the ferry *Seattle*, and provided faithful service well into the 1930s. (Courtesy of PSMHS photo collection, Neg. No. 1108-15)

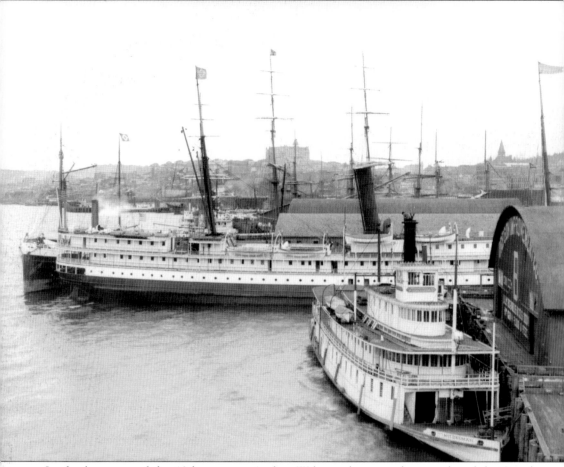

In the last years of the 19th century, Anders Wilse took many photographs of the Seattle waterfront. This photo, taken between 1897 and 1900 shows steamboats near the coal docks of the Oregon Improvement Company. These vessels used coal to fire their boilers. The *Multnomah* (foreground) made regular runs between Olympia and Seattle. The tall masts of sailing ships can be seen in the distance. (Courtesy of MOHAI, Neg. No. 88.33.225)

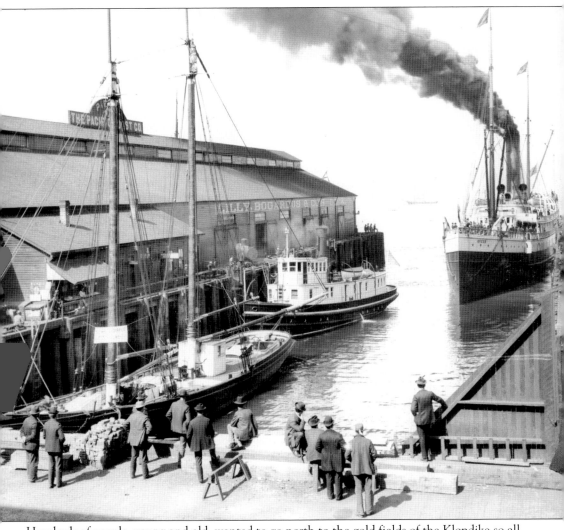

Hundreds of people, young and old, wanted to go north to the gold fields of the Klondike so all sorts of boats and ships were pressed into service. This photo, taken in 1898 or 1899, shows a group of onlookers viewing the steamer *Queen* (right) and a small wooden schooner (left). The sign by the schooner reads "Arctic Direct May 2." (Courtesy of MOHAI, Seattle Historical Society, Neg. No. SHS 2,075)

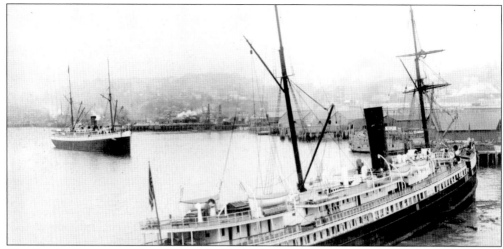

The Pacific Coast steamship *City of Puebla* backs away from her berth as her running mate *Umatilla* waits her turn to tie up. The photo was taken within months of the Great Seattle Fire of June 1889 during the flurry of construction along the waterfront. The fire consumed most of the piers, warehouses, and the downtown core now known as Pioneer Square. At the time of the photo the *City of Puebla* was one of the finest steamships serving on the West Coast. She ran on the Pacific Coast until 1916. The *Umatilla* also had a long career on the coast; having been built originally as a collier, she was rebuilt as a passenger ship in 1888 and continued until 1918. The old sidewheeler in the background is *Eliza Anderson*, dating back to 1859, finally ending in Alaska during the Yukon Gold Rush. (Courtesy of Mark Shorey)

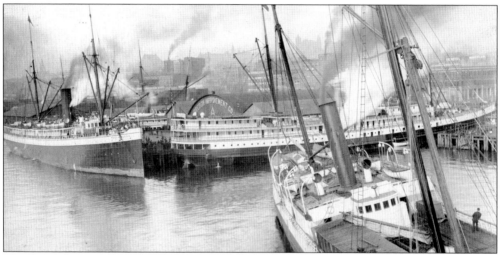

This busy photograph was probably taken during the Gold Rush years, and certainly before January 2, 1902, as the steamer on the left, *Walla Walla*, was rammed and sunk by the French bark *Max* off the California coast with a loss of over 30 people. The other steamships in the picture are *Queen*, and, in the foreground, *Alki*. Both were owned by the same company, Pacific Coast Steamship Company, which was the largest carrier on the Pacific Coast at the time. The *Queen* was one of the mainstays on the Seattle to San Francisco route. She was originally the *Queen of the Pacific* and had been built on the East coast in 1882. The smaller steamer *Alki* spent most of her career running to Alaska. The structures built on her foredeck are pens for livestock being shipped north. (Courtesy of Mark Shorey)

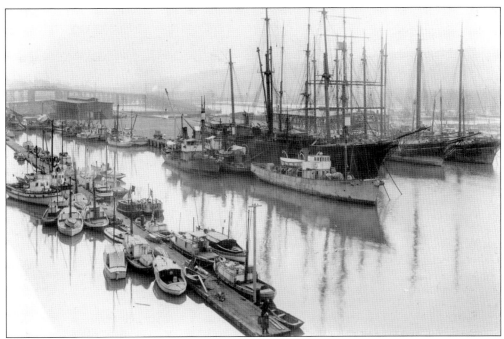

Fisherman's Terminal, on Salmon Bay, has been owned and operated by the Port of Seattle since 1913. This early day photo, looking southwest, was taken while the Bay was still salt water. Upon completion of the locks, the terminal became a fresh water moorage. Note the codfish schooner on the right alongside a rigged-down sailing ship. Three steam whaling vessels occupy the center with a collection of salmon seiners, trollers, and pleasure craft on the left. (Courtesy of MOHAI, Neg. No. 10657)

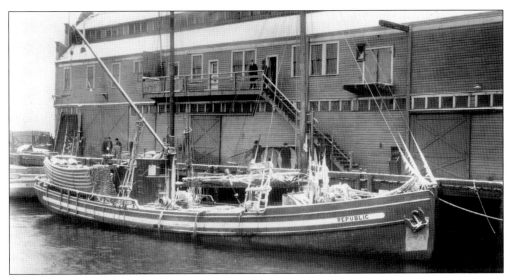

Republic is an auxiliary halibut schooner, and was built in 1913 by John Strand, Harold Lokken's grandfather, and is shown at Pier 8, now Pier 59, in Seattle in the 1920s. Note the ice in the rigging and the six dories stacked on deck. Fishing was done with hand lines, two men to a dory, until the early 1930s. Sails were used for steadying and, with a fair wind, to supplement the schooner's engine. (Courtesy of Harold Lokken, MOHAI photo collection, Neg. No. 6692-1)

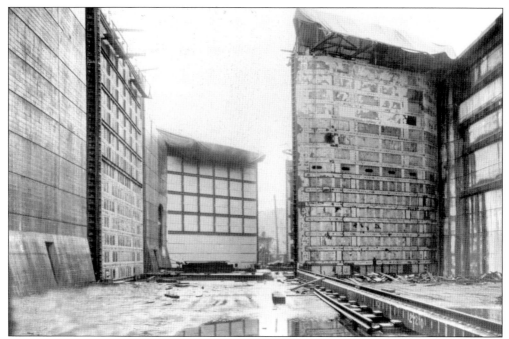

This photo taken in 1915 shows the lower service gate of the large lock. Vessels are lifted or lowered from 6 to 26 feet depending on the tide and water level of the lakes. The lock level is raised by opening a valve in the upstream level, allowing fresh water to flow in until it reaches the same height as the lake, and lowering is done in an opposite manner. The water then flows out into Puget Sound until the lock level is equal to that of the Sound. (Courtesy of National Archives, RG 77, Seattle)

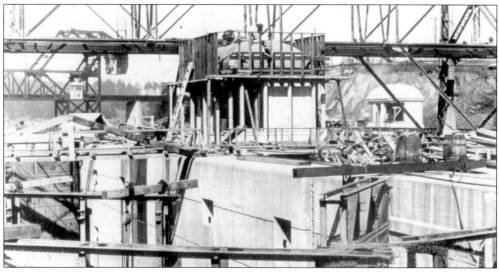

After 40 years of debating various options in connecting Lakes Union and Washington to salt water, Major Hiram M. Chittenden of the Army Corps of Engineers recommended a dual set of locks and a dam at the opening to Salmon Bay and excavation of the Fremont and Montlake cuts. The photo shows construction of the lock walls and Operating House No. 4. (Courtesy of National Archives, RG77, Seattle)

Hiram M. Chittenden received his commission from West Point in 1884. When he was assigned to the Puget Sound district, he was promoted to major and ordered to report on the most feasible method of constructing the Lake Washington Ship Canal. His report led to the June 25, 1910, authorization for the project as it exists today. Ill health forced his retirement in 1910, with the rank of Brigadier General, but he remained interested in the canal and was one of the organizers and first commissioners of the Port of Seattle, incorporated in 1911. He died in 1917 just three months after the official opening of the canal. The ship canal locks were officially designated as the Hiram M. Chittenden Locks by Congress in 1956. (Courtesy of Washington State Historical Society Library)

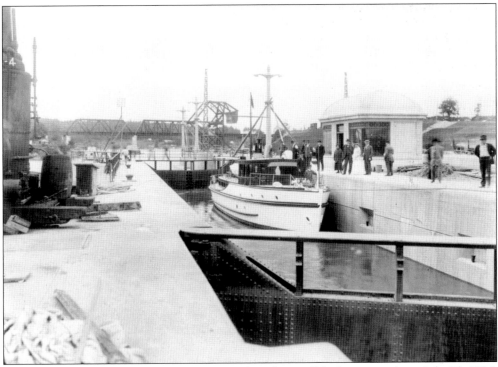

The Corps of Engineers launch *Orcas* is raised in the small lock on a trial run July 25, 1916. Construction began in 1911. The small lock is 150 feet long by 28 feet wide and can fill or empty in about 10 minutes. The large lock is 825 feet long by 80 feet wide and requires an average of 20 to 25 minutes. (Courtesy of National Archives, RG77, Seattle)

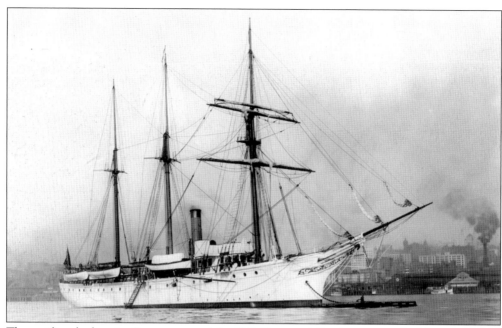

The auxiliary barkentine *Patterson* served the U.S. Coast and Geodetic survey for 35 years. Built at Brooklyn, New York, in 1882, she arrived on the West Coast in 1908. During her yearly voyages to Alaska, the crew conducted wire drags to locate underwater obstructions. Shore parties took astronomical observations and performed the survey work required to locate permanent markers. After construction of the Chittenden Locks, the Coast and Geodetic Survey fleet was moored at the south end of Lake Union. (Courtesy of Coast Guard Museum Northwest, Neg. No. 89.87/3)

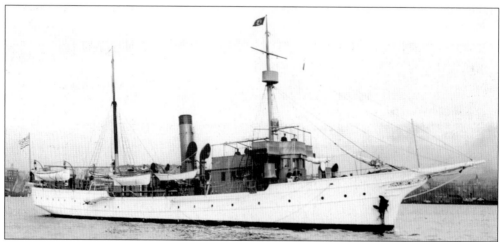

Explorer was built in 1904 for the U.S. Coast and Geodetic Survey. She arrived in Seattle in 1907 and began her work in Alaska. The crew was responsible for the fieldwork that would be used to update nautical charts and editions of the *Coast Pilot* publication. She was taken into the Navy in World War I and operated by the Corps of Engineers in World War II. Surplused after the war, new owners eventually converted her to a two-mast schooner. She met her end in the Caribbean in 1981. Joe Williamson, to whom this book is dedicated, once served as a sailor on this ship, in an era when crew members "holy stoned" wooden decks and slept in hammocks. (Courtesy of Coast Guard Museum Northwest, Neg. No. 89.87-2)

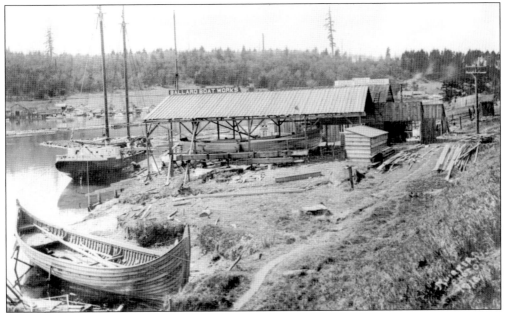

Sievert E. Sagstad opened the Ballard Boat Works about 1906 on the inlet between Shilshole Bay and Salmon Bay. This view looks roughly west southwest toward Fort Lawton on the Magnolia shore. The Chittendon Locks and the Great Northern Railroad Bridge are out of the photo to the left. Sagstad built the Viking boat replica in the left foreground for the 1909 Alaska Yukon Pacific Exposition. He built it in Bothell so it could sail down Lake Washington to the AYP, for there was no connection from salt water to the AYP site in 1909. The replica was moved to the Ballard Boat Works after the locks were opened in 1917, which dates this photo after 1917 and before Sagstad moved his business inside the locks about 1924. (Courtesy of MOHAI photo collection, Neg. No. 15167)

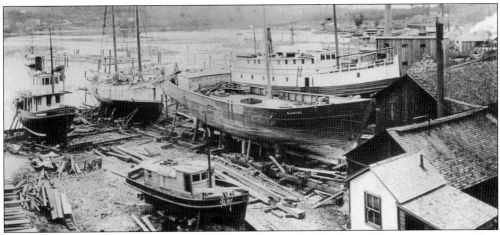

The King & Winge Shipyard was opened by Thomas J. King and Albert M. Winge in West Seattle about 1899. It was located adjacent to the southeast side of the Luna Park amusement park. This view looks roughly southeast across the Duwamish River delta. The shipyard is probably best known for the vessel *King & Winge* launched in 1914 and immediately pressed into service in the Arctic where she successfully rescued 12 survivors of the *Karluk*, trapped in the ice at Herschel Island. (Courtesy of PSMHS photo collection, Neg. No. 3909-1)

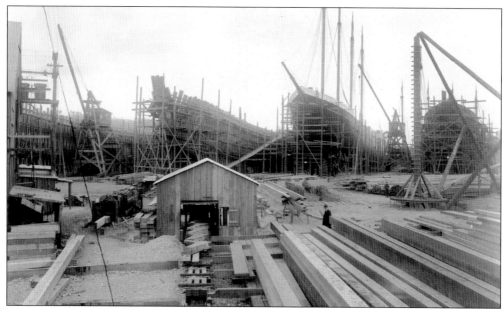

Shown here are four-masted auxiliary schooners being built at the Puget Sound Bridge & Dredging Company of Seattle. Puget Sound Bridge built four of these auxiliary schooners for the Norwegian-owned Pacific Motorship Corporation. They were *Tacoma, Portland, Remittent,* and *Risor,* all launched in 1916, followed by six similar auxiliary schooners for the French government. (Courtesy of PSMHS, Neg. No. 4924-18.)

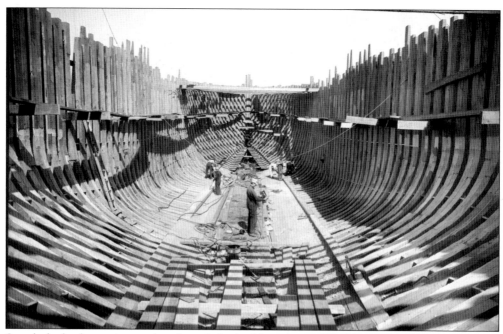

Seattle had a boom in wood and steel shipbuilding during World War 1. This photo, taken around 1918, shows men working on a wooden ship's hull at the National Shipbuilding Company. (Courtesy of MOHAI, PEMCO Webster & Stevens Collection, Neg. No. 83.10.10545)

Though wooden hulled ships were built in the Seattle area for many years, local shipyards began building steel-hulled ships when the U.S. entered World War 1 in 1917. In this photo, a Seattle shipyard worker prepares to rivet a steel plate on the deck of a large ship. (Courtesy of MOHAI, PEMCO Webster & Stevens Collection, Neg. No. 83.10.10621)

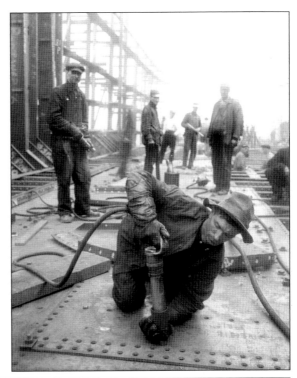

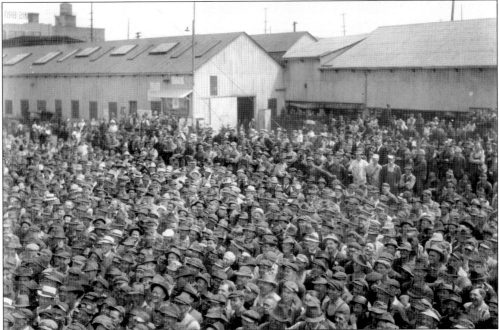

This striking photo shows workers at the J.F. Duthie & Co. shipyard. The Duthie yard began operation in 1912 with the building of the steel whaling steamers *Kodiak* and *Unimak* and the fishing steamer *Starr*. In World War I they built 24 of the 8,800 deadweight ton "Robert Dollar" or "West" class of standard steel Shipping Board freighters, along with two smaller cargo steamers for Captain Griffiths' Coastwise Steamship & Barge Co. (Courtesy of PSMHS, Neg. No. 6727)

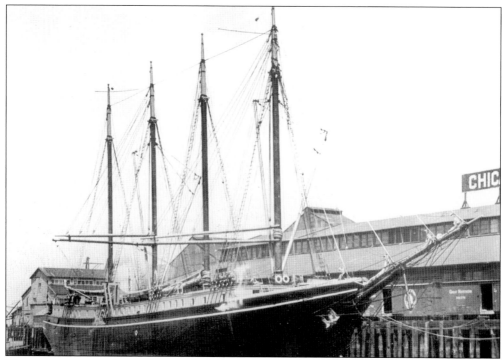

The twin-screw auxiliary schooner *La Merced* was built during World War I and operated by the Standard Oil Co. Later converted to a floating fish saltery and cannery, she made annual voyages to Alaska under both sail and power. The marine crew was Caucasian while the cannery hands were mostly Filipino-American. She remained idle on Lake Union for many years and ended up as a breakwater at Anacortes. (Courtesy of Bill Saxby photo collection)

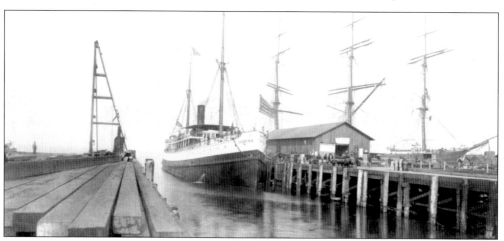

The new steamship *Corona* is shown at the Oregon Railway and Navigation Company dock. From the Company's fabric banner and the pile driver in the background this photo was probably taken soon after the Great Seattle Fire of June 6, 1889. *Corona* was built in Philadelphia in 1888 and arrived in Seattle in March 1889. She ran throughout the summer of that year to Alaska, which already was becoming a tourist destination. She spent most of the 1890s running out of San Francisco on routes as far south as San Diego and as far north as Skagway. She was finally wrecked on Humboldt Bay in 1907. (Courtesy of Mark Shorey)

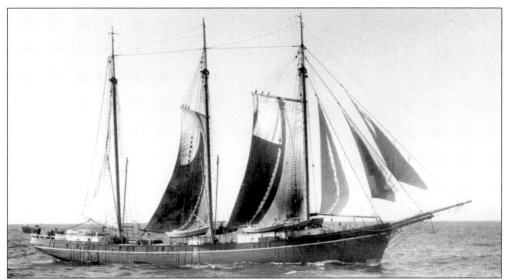

The three-mast schooner *Wawona* was built for the coastwise lumber trade in 1897. By 1914, steamships had mostly displaced sail and she was sold into the codfish trade. Fishing was done along the Alaska Peninsula with handlines from dories. The catch was split, salted, and stored in the hold. Upon return to Puget Sound, the fish were further processed, dried, and shipped to a worldwide market. *Wawona* is now a museum ship in Seattle. (Courtesy of PSMHS photo collection, Neg. No. 2726-12)

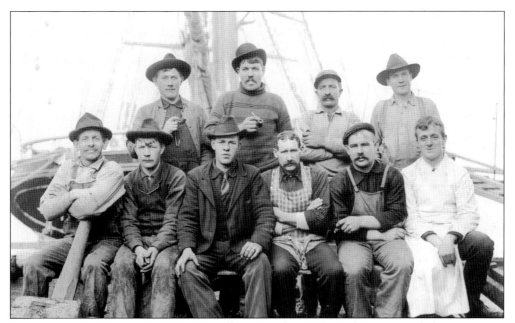

Sailing vessels were a common sight in Elliott Bay during the early 1900s, and the crews were often asked to pose for photos. Here is the crew of the famous three-masted bark *Hesper*, in the background, taken around 1903. *Hesper* was launched on October 12, 1882, at Port Blakely at the Hall Brothers shipyard. *Hesper* was noted for a mutiny that occurred on a voyage from Newcastle to Honolulu in 1893. (Courtesy of MSCUA, Univ. of Washington, Wilhelm Hester Collection, Neg. No. 10460)

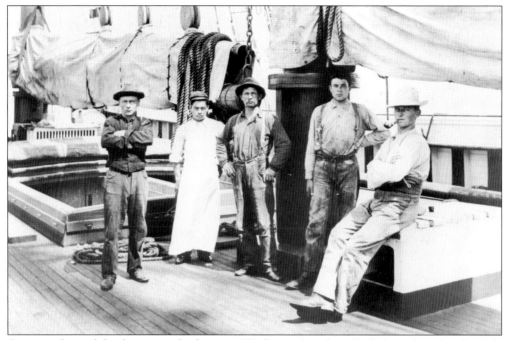

Crewmembers of the four-masted schooner *Winslow* gathered on deck for a short break while the noted northwest photographer Wilhelm Hester took their picture, c. 1904. *Winslow* was launched in 1899 at the Hall Brothers yard at Port Blakely and was a frequent visitor in Puget Sound waters. She was named after one of the Hall Brothers owners, Winslow G. Hall. *Winslow* was sunk by the German Raider *Wolf* in the South Pacific on June 6, 1917. (Courtesy of MSCUA, Univ. of Washington, Wilhelm Hester Collection, Neg. No.107047)

This wartime view of a French "Bounty bark" was taken at the Bell Street terminal, Seattle in 1915. The war had swept away all German shipping, but French ship owners continued to send their numerous square riggers over the world's oceans in search of paying cargoes. Being subsidized by the French government at a rate of francs per gross tons per miles sailed, there was ample inducement to go tramping, in ballast for a paying cargo no matter the absence of revenues earned. This unidentified bark apparently has arrived in port, rust-streaked, in hopes of finding a paying cargo, very likely Northwest grain for Europe. The long forecastlehead and characteristically low level hawse pipe, close to the waterline, was typical of the French Bounty ships. (Courtesy of MSCUA, Univ. of Washington, James P. Lee Collection)

The 42-foot racing sloop *Spirit* was built on top of Queen Anne Hill and hauled down the counterbalance to her christening by a team of four horses. Crafted by Lloyd & Dean Johnson to the plans of designer/skipper L.E. "Ted" Geary, she was launched in 1907. Still in his teens at the time, Geary already showed the skills that created so many fine yachts, both sail and power. (Courtesy of PSMHS, Neg. No. 4470-3)

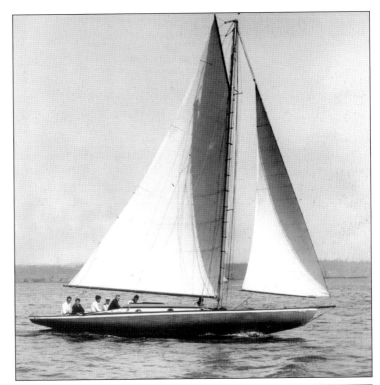

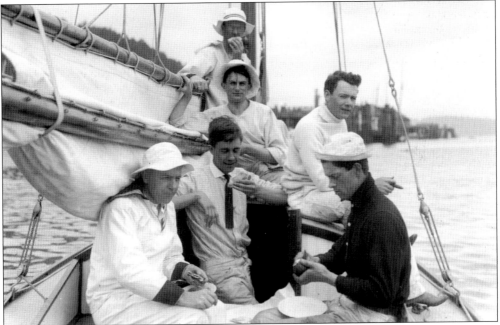

Between races at the 1907 Alexandra Cup regatta, the crew of *Spirit* shares a quiet moment over the last of their lunch while moored off of the Seattle Yacht Club in West Seattle. Skipper Ted Geary stands in the companionway while syndicate head Scott Calhoun (in the white pinafore) chews his pie. *Spirit* won the cup from the Canadian *Alexandra*, two races to one. (Courtesy of PSMHS, Will E. Hudson collection, Neg. 879-28)

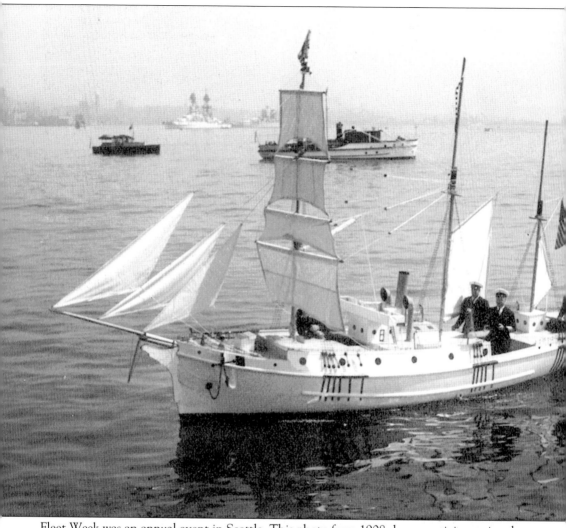

Fleet Week was an annual event in Seattle. This photo from 1908 shows participants in a boat parade. Two Chief Boatswains Mates from the revenue cutter *Bear* are proudly sailing a launch converted into a replica of their famous ship. Note the battleships anchored in the background. (Courtesy of the Coast Guard Museum Northwest)

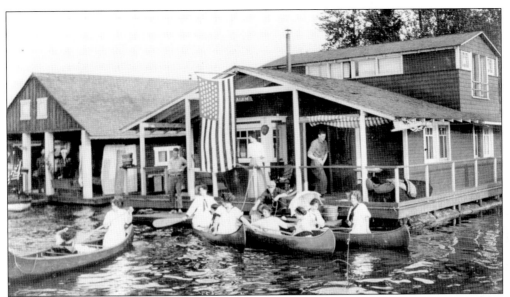

Houseboats have always been a unique feature of Seattle's inland waters. This two-story residence is an early example, shown here in 1912. Note the female canoeists visiting here, perhaps on the Fourth of July, judging by the gigantic American flag on display. Canoeing was a popular activity and means of transportation on Lake Washington in earlier days. This houseboat is still in existence today, having been moved from its probable moorage at the foot of Madison Street to its present location on the west shore of Lake Union. For the last 40 years or so it has been the home of Society members Colleen and Dick Wagner. (Courtesy of MSCUA, Univ. of Washington, Neg. No. Lee20035, James P. Lee Collection, No. 294.)

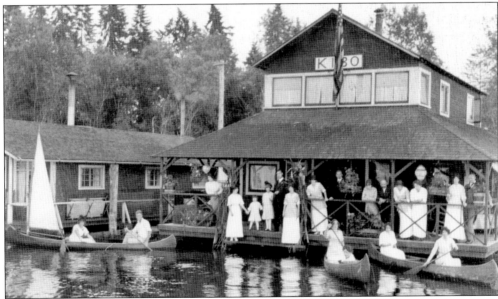

This is a view of another two-story houseboat moored on the shore of Lake Washington in 1912, probably at the foot of Madison Street. Note the sail on the canoe at far left of the photo. Many boaters enhanced their canoes by the use of conventional and outrigger sails. (Courtesy of MSCUA, Univ. of Washington, Neg. No. Lee20105, James P. Lee Collection, No. 294.)

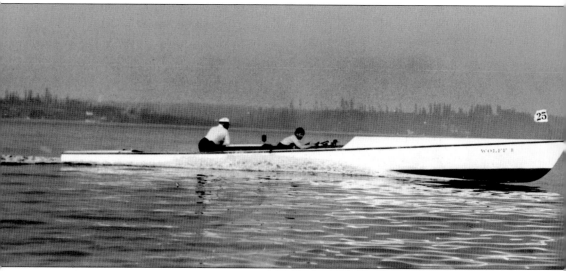

This 12-meter (length overall) hydroplane *Wolff II* was designed and built by Capt. John E. Wolff of Portland. For the Alaska Yukon Pacific Exposition Regatta (AYP) in 1909, she was based at the Howard's Shipyard at Madison Park, a short distance from the start/finish line in Union Bay. Powered by a four cylinder, two-stroke Smalley, she easily won all races entered including a 60-mile endurance event. In the photograph, taken shortly after the start of a race, Captain Wolff is seen at the throttle while co-owner Capt. E.W. Spencer steers from the aft position. (Courtesy of PSMHS Neg. No. PS879-73)

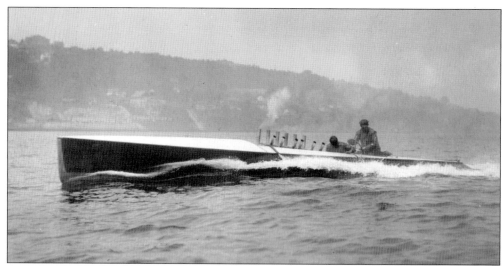

The local hope at the AYP races was *Seattle Spirit*, a bright red, 10-meter boat completed just before the regatta. Too new, *Spirit* suffered from lack of preparation and failed to finish all but one race. A year later, the same boat dominated the Pacific Coast Championships by finishing first among the 10-meters and besting the time of the bigger *Wolff II* to take the title of "Fastest Boat on the Pacific Coast." Owner/builders Ralph Casey and Charles Binkley of the Seattle Yacht Club credited better preparation and a special propeller designed by Leigh H. Coolidge for the extra speed. By 1911, the *Seattle Spirit*, *Wolff II*, and *Pacer* teams were all using Seattle-made Coolidge propellers exclusively. *Spirit* was powered by a six-cylinder, four-cycle Scripps gasoline engine rated at 100 h.p. (Courtesy of PSMHS Neg. No. PS879-51)

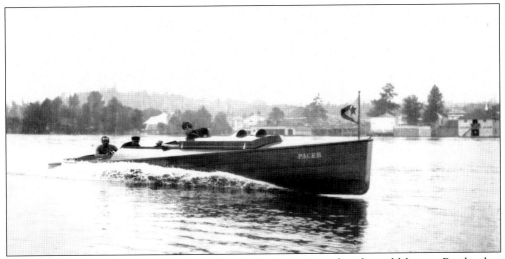

The 10-meter boat *Pacer* was built in New York. Louis Roesch, who sold her to Portlanders prior to the AYP, brought *Pacer* to Seattle. Roesch and his brother handled the boat for the regatta, however. *Pacer* was powered by a six-cylinder, 120-horsepower Leighton engine. Her varnished hull was much broader aft than *Wolff*'s although she was nearly seven feet shorter. The photograph shows the Madison Park shore of Lake Washington with the Cascade Canoe Club boathouse, right. *Pacer* finished second to *Wolff II* in all of the open-to-all races and won the 10-meter trophy. (Courtesy of PSMHS, Neg. No. PS879-50)

Wolff II	*Pacer*	*Seattle Spirit*
LOA 39'-9"	LOA 32'-0"	LOA 32'-9"
BEAM 4'-5"	BEAM 5'-6"	BEAM 4'-6"
DRAFT 8"	DRAFT 9"	DRAFT 10"

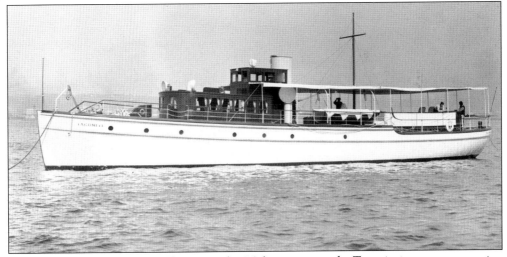

One of the trimmest vessels of her time, the 96-foot motor yacht *Taconite* is seen at a mooring in Elliott Bay. She was one of a number of vessels by that name owned by industrialist William E. Boeing. *Taconite* was designed by H.J. Gielow of New York and built in 1910 by E.W. Heath at his shipyard on the Duwamish River. Later, Boeing would purchase Heath's yard as the site for the Boeing Airplane Company Plant No. 1. (Courtesy of PSMHS, Neg. No. 4503-1)

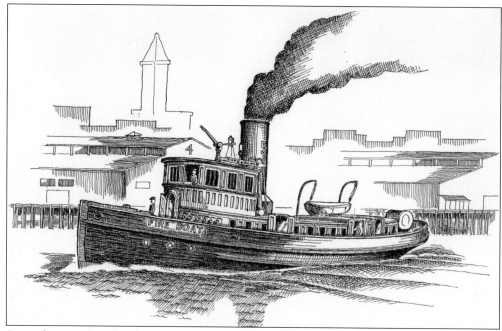

Snoqualmie was Seattle's first fireboat, built one year after the Great Seattle Fire of June 6, 1889. She was 90 feet long, had a wood hull, and could pump 5,765 gallons of water per minute. She protected the highly flammable waterfront piers, buildings, and sawmills before being joined by *Duwamish* in 1909. (Courtesy of the Fletcher family, drawing by Ronald R. Burke)

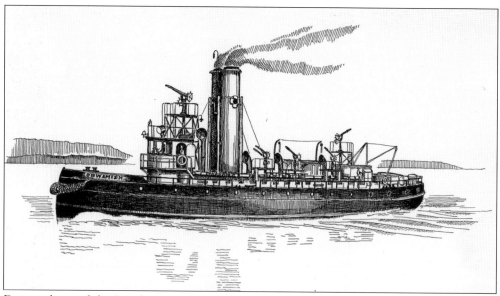

Duwamish joined the Seattle Fire Department in 1909. She has a riveted steel hull 120 feet long and a ram bow designed to sink burning wood vessels when their fires were out of control. Her original design called for a twin-screw steamer capable of 10 knots with a pumping capacity of 9,000 gallons per minute. Together with *Snoqualmie* she fought the Grand Trunk Dock fire on July 30, 1914. The city converted *Duwamish* to diesel in 1949, and she is currently a museum ship. (Courtesy of the Fletcher family, drawing by Ronald R. Burke)

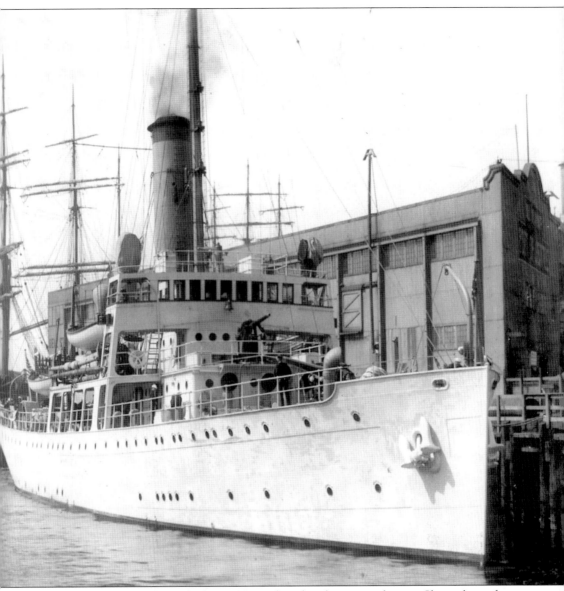

Coast Guard Cutter *Haida* was built in 1921 with turbo-electric machinery. She is shown here at the Port of Seattle Bell Street Terminal in 1923. Note the masts of two square rig ships behind the building. They were old "Downeasters" built in Maine which ended their days in the cannery trade. *Haida* spent her years on the Bering Sea Patrol engaging in law enforcement, search and rescue, arctic research, and, during wartime, convoy and weather ship duty. (Courtesy of Coast Guard Museum Northwest, Neg. No. 89.117/54)

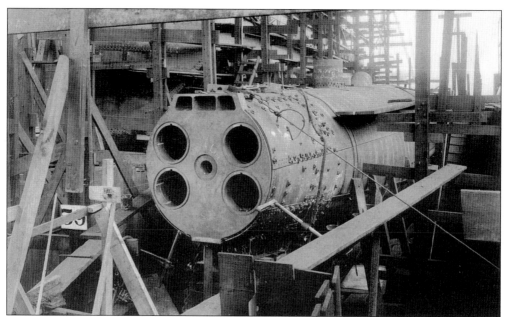

The submarine *USS H-3* (originally *Garfish*) under construction at the Moran shipyard on the Seattle waterfront. *H-3* was launched July 1913. She is most noted for having been hauled overland across Samoa Spit to be re-launched into Humboldt Bay in California, after a spectacular grounding and salvage effort on the eve of U.S. entry into World War I. (Courtesy of Roland Webb from National Archives)

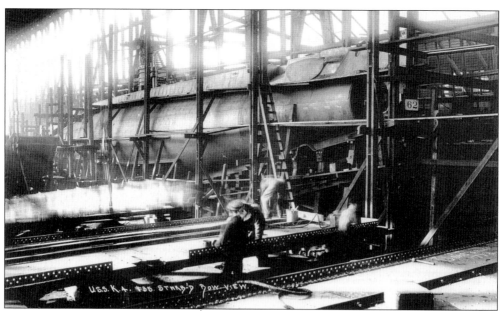

USS K-4 was one of only nine navy submarines ever constructed in Seattle, all before the end of World War I. Here, at the Seattle Construction and Dry Dock Company (previously known as the Moran yard), she shows nearly completed plating, superstructure, and conning tower. *K-4* represents the largest submarine built in Seattle at 153 feet long and 521 tons submerged displacement. (Courtesy of Roland Webb from National Archives)

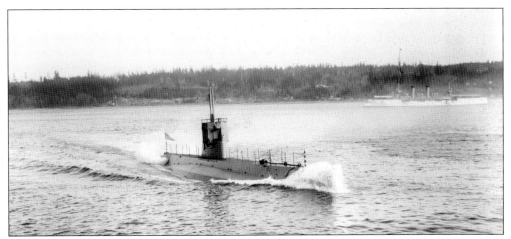

On a chilly day in March 1914, from behind the protective canvas dodger, skipper Lieutenant Munroe pilots submarine *USS H-3* back to Puget Sound Navy Yard after refueling in Seattle. The highly visible, telltale white plume of exhaust bedeviled all the submarines powered by the newly designed, two-cycle NELSECO diesel engines. (Courtesy of Washington State Historical Society, Curtis Neg. No. 28779)

Repair work was a significant part of the Todd Shipbuilding Corporation's work in Seattle. Here we see two vessels undergoing repairs and refurbishing. The large steamer on the far end of the drydock is unidentified. The vessel with the bow forward is a World War I Navy Patrol Boat *S.P. 1351*, with staging constructed around the waterline of the patrol boat where work crews could repair and paint the bottom of the vessel. The large sailing vessel to the left is unidentified, but it was not uncommon for these large ocean-going vessels to come in for repairs or discharge cargo. (Courtesy of PSMHS, Neg. No. 6287-10)

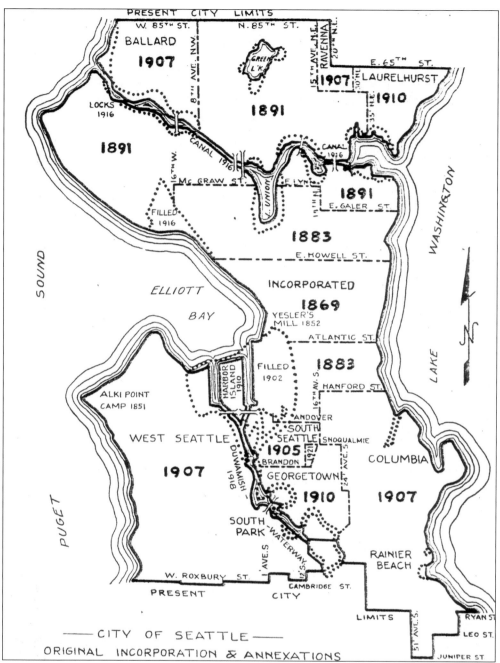

Pictured are Seattle shorelines as they appeared in 1938, showing annexation boundaries and dates along with major municipal civil engineering projects. The city became nationally known for its ambitious fill and regrade efforts. Work included cutting hills down with hydraulic jets that would wash the material into Elliott Bay, and also for filling the tide flats at Smith Cove, the base of Beacon Hill, and at West Seattle. The serpentine Duwamish River was dredged and straightened, reducing its length from 13 to 4 miles. The Hiram Chittenden Locks and Ship Canal opened Lakes Union and Washington to ship traffic from Puget Sound and lowered by nine feet the level of Lake Washington. (Courtesy of MSCUSA, University of Washington)

58

Three

COMMERCE AND CONFLICT
DEFINE THE WATERFRONT:
THE DEPRESSION YEARS

Following the industrious days of rebuilding Seattle after the Great Fire, bringing in railways, digging the Lake Washington Ship Canal, leveling Seattle's hills, and major developments in the port and shipbuilding industries, labor became restless. Conflicts between the American Federation of Labor (A.F. of L.) and the more radical Industrial Workers of the World (IWW), as well as between the unions and their employers, often became deadly. In 1919, Seattle's shipyard workers, united under the Seattle Metal Trades Council, threatened to strike. Actions to avert the strike by the Federal Government infuriated labor, and a general strike was called on February 6, 1919. The five-day strike was conducted in a very orderly fashion with no violence. Milk was delivered to hospitals, to the ill, and to babies, but all other commerce was shut down.

The regrading of Seattle's hills continued on into the 1920s. A paved Alaskan Way and a sea wall replaced the old wooden-planked Railroad Avenue that had been built on piles. A railroad tunnel was constructed under the city connecting the waterfront to the depot. The freight yards south of the King Street Station were constructed on filled tidelands, as were the sports stadiums, and much of the industrial base south of downtown, as well as Harbor Island.

Intercoastal cargo and passenger traffic declined as roads, automobiles, and trucks slowly took over. The mosquito fleet of small vessels declined. The last scheduled route on Puget Sound was abolished in 1939. Privately owned passenger ferries carried people and vehicles.

The depression years of the 1930s saw the creation of several "Hoovervilles" on the waterfront and in other parts of town. To add to the labor unrest and political confusion, Seattle entered a period of severe strife. The International Longshoreman's Association (ILA) tried to organize the longshoremen in 1934. This was bitterly opposed by the Waterfront Employers Association (WEA) who hired strikebreakers and enlisted the city's police and

their own armed guards. The strike lasted for 98 bloody days and cost millions of dollars in the middle of the depression, creating bitterness throughout all layers of the city. Federal mediators sent in by President Roosevelt settled the strike. The ILA was permitted to organize and to run the hiring halls. Additional strikes and battles over warehousemen raged between the ILA and the Teamsters' Union (led by Dave Beck, West Coast organizer of the Teamsters).

(*previous page*) Two old ships, *Lady Cynthia* and *Union 1*, are being cut up for scrap on the beach at Shilshole outside the Government locks entrance, as seen in this drawing by artist Hewitt Jackson in 1959. (Courtesy of the artist Hewitt Jackson)

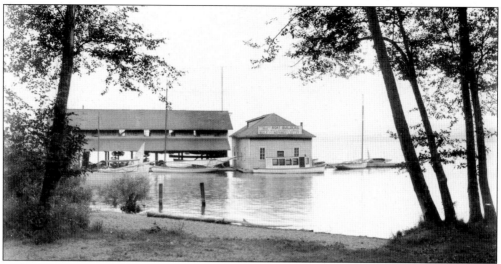

William and Frank Schertzer operated a boathouse and boat building company on the shores of Lake Washington at Madrona Park between 1902 and 1917. (Courtesy of MOHAI, PEMCO Webster & Stevens Collection, Neg. No. 83.10.7869)

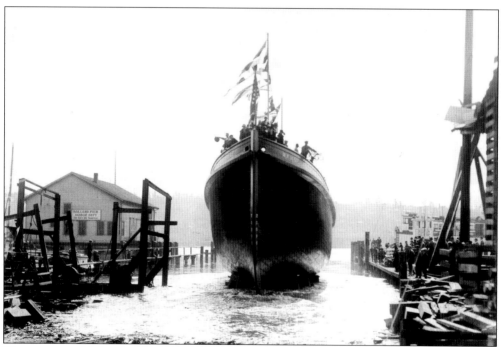

The ocean tug *Mahoe*, built at the Ballard Marine Railway Company for a Honolulu company, is shown during the April 1925 launch ceremony. At the time of its launching, the 120-foot tug was the largest diesel tug in the world. The vessel is decorated with flags and carries a group of waving passengers. (Courtesy of MOHAI, *Seattle Post-Intelligencer* Collection)

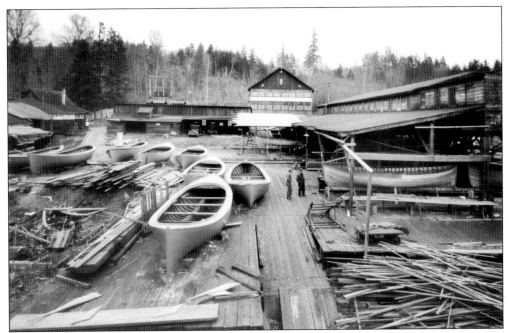

In 1924, the Lake Washington Shipyards Corporation opened a yard at Houghton, on the eastern shore of Lake Washington. The boats being built are similar to the 30-foot Bristol Bay hulls that were extensively used for fishing. (Courtesy of MOHAI, PEMCO Webster & Stevens Collection, No. 83.10,384.5)

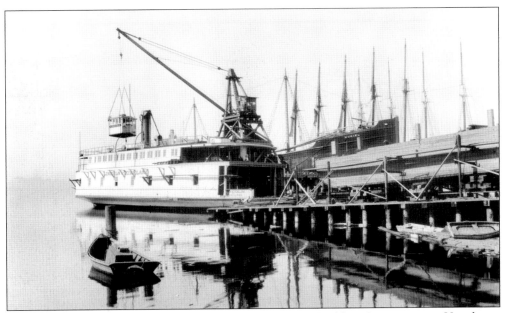

The ferry *Lincoln* was launched in 1914 from Anderson Shipbuilding Corporation in Houghton, on Lake Washington. It was refurbished at the same yard shown here in 1923. The ferry ran between Leschi and Madison Park to Kirkland until 1945. The five-masted schooner beyond is the uniquely rigged *Columbia River*. (Courtesy of MOHAI, PEMCO Webster & Stevens Collection, No. 83.10.2530.2).

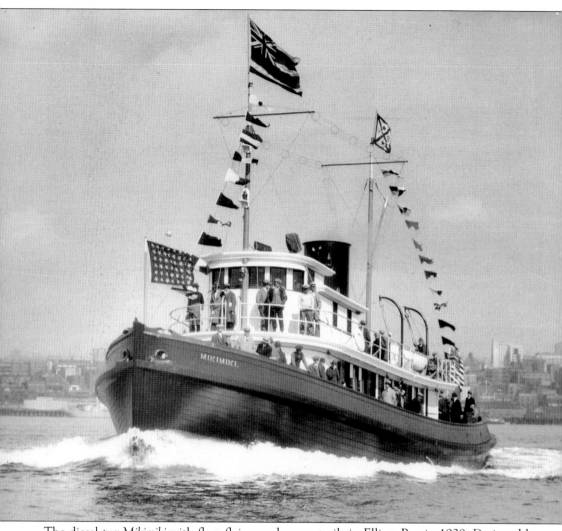

The diesel tug *Mikimiki* with flags flying on her sea trails in Elliott Bay in 1929. Designed by Seattle naval architect L.H. Coolidge, this 125-foot vessel was built by the Ballard Marine Railway Company and fitted with twin Fairbanks-Morse engines, making her the most powerful diesel tug in the world. Her basic design became the model for developing a huge fleet of tugs built for government service during World War II. (Courtesy of MOHAI, Neg No. shs 12011)

In 1924, Capt. John A. O'Brien ("Dynamite Johnny") is shown with Buster Keaton, famous comedian for silent movies, in this still publicity photo for the movie *The Navigator*. He was born in Cork, Ireland, and served in sail from 1867 to 1883 where he became known for his fiery temper. Yet the name "Dynamite Johnny" was ascribed to him not because of his temper, but because of actions he took as third mate on steamer *Umatilla*, in a storm off Cape Blanco. He was able to save the ship by subduing a safe that was rolling back and forth battering a case of dynamite—hence the name. Starting in 1888 he was master of many steamers, mostly on the Alaska run. For many years his ships were the first into and last out of Nome each season. After 1919 he was a Puget Sound pilot. He passed away in Seattle, age 80. (Photo from PSMHS photo collection, Neg. No. 1677-3)

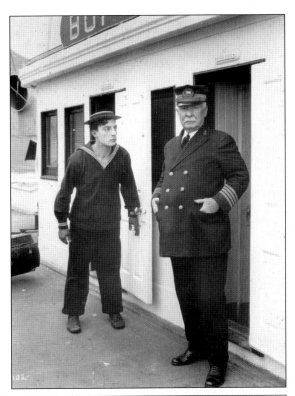

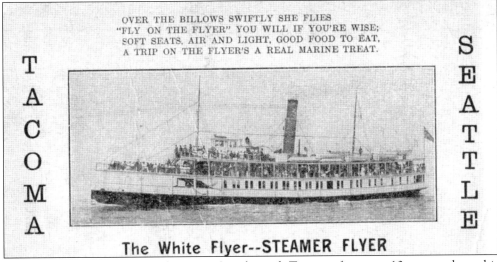

OVER THE BILLOWS SWIFTLY SHE FLIES
"FLY ON THE FLYER" YOU WILL IF YOU'RE WISE;
SOFT SEATS, AIR AND LIGHT, GOOD FOOD TO EAT,
A TRIP ON THE FLYER'S A REAL MARINE TREAT.

TACOMA

SEATTLE

The White Flyer--STEAMER FLYER

Flyer had been on the run between Seattle and Tacoma for over 10 years when this advertisement came out in 1903. She had been built in Portland, Oregon, in 1891 for this route and ran on it well into the 1920s. She was one of the most popular steamers on the Sound even after newer steel hulled steamers began running the route in the first decade of the 20th century. Everyone wanted to "Fly on the Flyer" and while steaming between the two cities at 16 knots it probably felt like they were indeed flying. She made four runs a day starting at Seattle at 6:45 in the morning and her last run leaving Tacoma was at 7:30 at night; it cost 35¢ for a one-way ticket. The travel times were scheduled to connect with other steamers throughout the Sound. (Courtesy of Mark Shorey)

Freight

Passengers

Refrigeration

For Rates and Information Call or Write

Alaska Transportation Co.

PIER 58, SEATTLE, WASH.
MA 7477

Alaska Transportation Co. (ATCO) was formed by a group of businessmen from the Seattle-Tacoma area in 1935. They established themselves in the southeastern Alaskan trade by initially operating two ships. During World War II they managed 19 ships for the War Shipping Administration, and after the war years they were one of three companies to compete in the highly competitive Alaska market. Hoping to enter the cruise business, they re-fitted the East Coast passenger liner *George Washington* and operated her in the 1948 season. A 95-day seaman strike beginning in September of that year led to liquidation of the company. (Courtesy of Ronald Burke advertisement collection)

A rare emblem of the Puget Sound Navigation Company, "The Black Ball Line," shows the fast passenger steamer *Tacoma*. Engineer Keith Sternberg found this artwork among the files of an old printing company once located in Seattle's Pioneer Square area. *Tacoma* was built for the Seattle-Tacoma route and, under command of Capt. Everett Coffin, ran from 1913 to her retirement in 1930 without an accident. (Courtesy of Keith Sternberg)

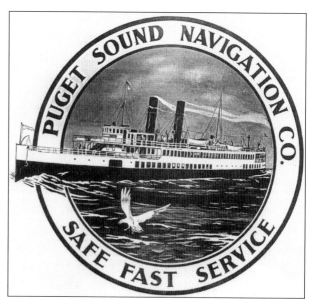

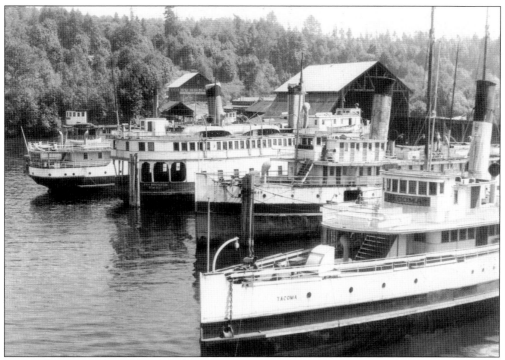

In October 1938, the Puget Sound Navigation Company sold five of its old passenger steamers to Seattle Iron & Metals Corporation for scrapping. *Tacoma, Kulshan, City of Bremerton, Indianapolis,* and *City of Angeles,* all former mosquito fleet vessels on Puget Sound, had been put out of business by the large new ferries which carried both passengers and automobiles. (Courtesy of MOHAI, Seattle Historical Society Neg. No. 2299)

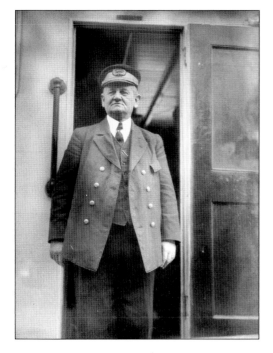

Capt. Everett Coffin is best known for commanding the legendary steamers *Flyer,* then *Tacoma,* for a total of 26 years on the Seattle to Tacoma run. These two speedy steamers set some impressive records during their service on the run. Together they covered 2.5 million miles. Captain Coffin was quoted as saying, "It was the longest voyage you could imagine to nowhere." He retired to a home on Alki Point where he could observe the passing maritime traffic and died there in 1950 at the age of 85. (Courtesy of Washington State Historical Society Library)

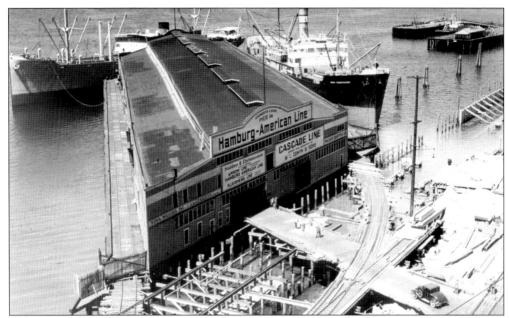

A typical waterfront scene in July of 1934, Pier 14, now Pier 70, is located at the foot of Broad Street on Alaskan Way, then known as Railroad Avenue. The mainline tracks, spurs, and planked roadway were all on pile-supported structures. The ship on the right is *Edwin Christenson* of the Arrow Line. A Scandinavian motor vessel lies across the head of the pier. After several restorations, Pier 70 still exists in much the same configuration. (Courtesy of MSCUA, Univ. of Washington, James P. Lee Collection. Negatives No. Lee 12552.)

The 70-foot tug *Chickamauga*, here at work towing a raft of logs toward the locks, was the first full diesel-powered vessel in the U.S. She was designed by L.E. "Ted" Geary and built at Seattle in 1915 by Nilsen & Kelez for the Pacific Tow Boat Co. *Chickamauga* still exists today at a moorage in Lake Union. (Courtesy of MOHAI, Neg. No. 499-3)

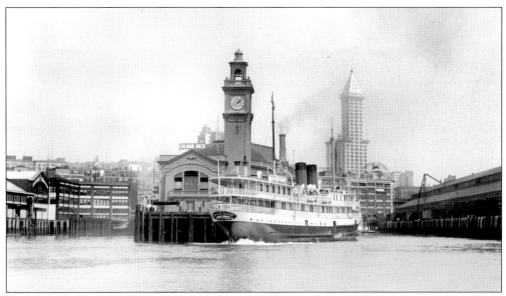

In the early days before car ferries, hundreds of small steamers competed to carry passengers and freight to the towns and islands of Puget Sound. They were called the Mosquito Fleet, which applied to the small wood hull boats. The definition was sometimes enlarged to include their larger steel hull sisters. *Iroquois*, shown backing out of the dock, was a handsome steel steamer brought around from the Great Lakes in 1907, and she spent most of her time on the Seattle-Victoria run. In 1927 she was converted to a car ferry, and continued until 1947 when her replacement, M.V. *Chinook* arrived. The venerable clock tower was toppled from the pier in 1935, but the clock face and works were restored and are displayed in the lobby of the present Washington State ferry terminal. (Courtesy of MOHAI, Neg. No. 83.10.10135)

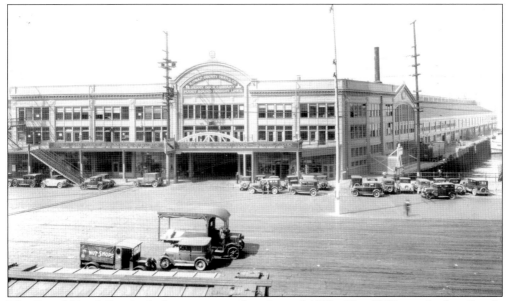

The Grand Trunk Pacific dock as it appeared in the mid 1920s. The GTP was the first Seattle home of Puget Sound Freight Lines and the *Marine Digest*, as well as being the Seattle terminus of the Kitsap County Transportation Company. (Courtesy of PSMHS, Lovejoy Collection)

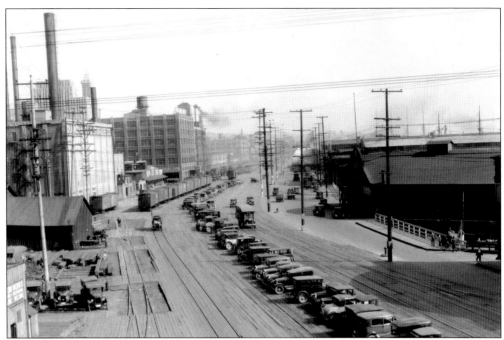

Railroad Ave South From Pike. (Courtesy of Seattle Muni Archives, Orig No. 8308, item No. 4073)

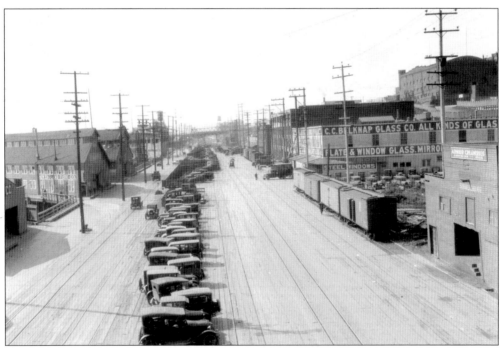

Before it was named Alaskan Way, it was known as Railroad Avenue. On May 5, 1930, the Seattle Engineering Dept. made this pair of photographs documenting Railroad Avenue, looking north and south from Pike Street. Six sets of railroad tracks flank the row of parked cars. (Courtesy of Seattle Muni Archives, Orig No. 8307, item No. 4072)

When men move mountains to make cities, something has to be done with the excess dirt. Much of the dirt was sluiced into Elliott Bay for landfill, but this photo shows a tug hauling a "self-dumping" scow at the foot of Battery Street with a load of dirt from the Denny Hill regrade. The top photo was taken on May 8, 1930, relatively late in the regrade project. The bottom photo shows the scow dumping its load into the Bay—another stage in the reshaping of Seattle's salt waterfront. (Courtesy of MSCUA, Univ. of Washington, Negatives Nos. Lee 20119 and Lee 20120, James P. Lee Collection No. 294.)

Capt. Frank Edward Lovejoy, known as "Cap'n Ed," was born in Coupeville on Whidbey Island in 1888. Trained as a naval architect and marine engineer, he, along with Clarence Carlander, founded Puget Sound Freight Lines in 1919. He became a prominent Seattle businessman in the 1920s, and was well known for his thoughtfulness, good nature, and humor. F.E. Lovejoy died suddenly of a heart attack on October 4, 1940. (Courtesy of PSMHS, Lovejoy Collection)

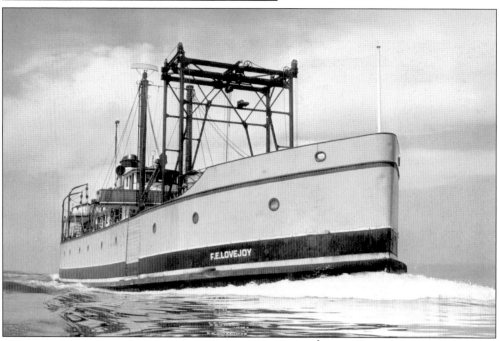

Launched in 1946 and named after the company founder, the F.E. Lovejoy was the Puget Sound Freight Lines' largest ship, at 188 feet. Until the 1970s P.S.F.L. used her to haul newsprint from Canadian mills into Puget Sound, much of which was put on rail cars for destinations all over the west. (Courtesy of PSMHS, Lovejoy Collection)

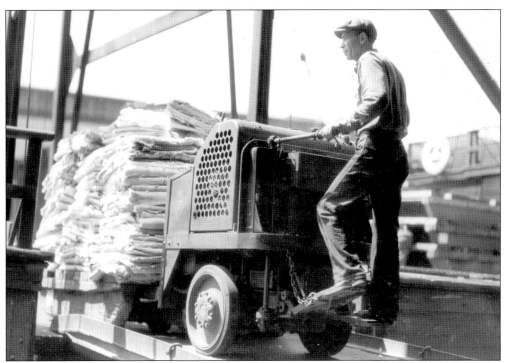

One of the mainstays of the Puget Sound Freight Lines' business was the shipping of pulp. In the early 1930s, the PSFL used ship-board elevators and "jitneys" to move pulp on skips, revolutionizing freight handling on Puget Sound. (Courtesy of PSMHS, Lovejoy Collection)

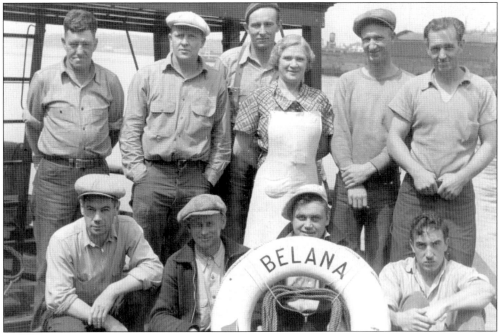

Some time in the late 1930s the crew of the Puget Sound Freight Lines boat *Belana* posed for a group portrait. (Courtesy of PSMHS, Lovejoy Collection)

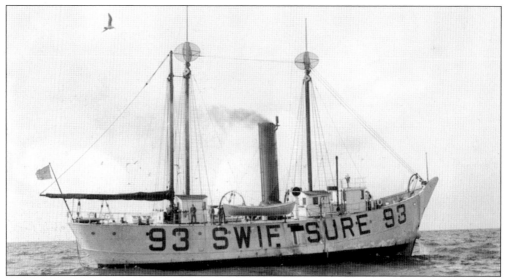

The U.S. Lighthouse Service stationed *Lightship No. 93* on the Swiftsure Bank at the entrance to the Strait of Juan de Fuca between 1909 and 1930. Lightships once served as aids to navigation where lighthouses could not be built. Her oil lamps would be hoisted up the masts from the lamp houses at their base. The lattice work day marks at the top of her masts could be seen by approaching ships while she was still hull-down over the horizon. Note the steam fog whistle at the top of the stack and the large bell forward of the pilothouse. Her hull was painted yellow to differentiate her from the Umatilla Reef lightship located about 22 miles south. (Courtesy of Coast Guard Museum Northwest, No. 86.47/73)

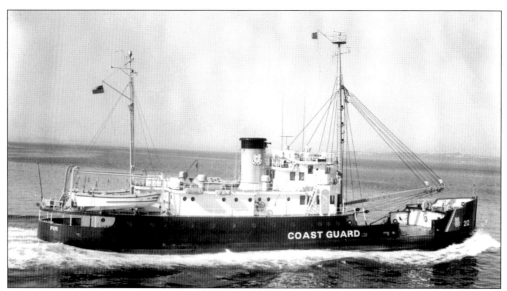

Buoy Tender *Fir* was built in 1939, the same year that the federal government merged the Lighthouse Service with the Coast Guard. She was twin screw with reciprocating steam engines and later converted to diesel. She spent her years maintaining aids to navigation in Puget Sound and the Strait of Juan de Fuca. At the time of her retirement in 1991, *Fir* was the oldest Coast Guard vessel in commission and is now scheduled to become an exhibit at the National Lighthouse Museum in New York. (Courtesy of Coast Guard Museum Northwest)

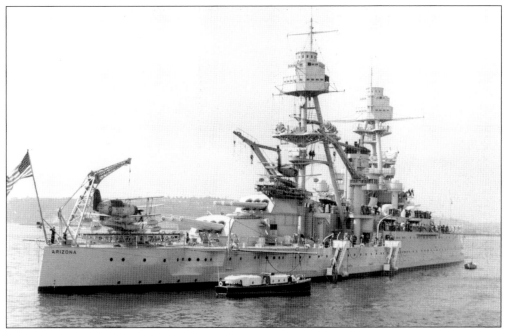

USS *Arizona*, photographed in the late 1930s, when she was anchored in Elliott Bay during Fleet Week. Ships were opened for public tours with transportation to and from provided by Navy shore boats. *Arizona* appears much as she did on December 7th, 1941, at Pearl Harbor when Japanese aircraft sank her. Her hulk remains as an underwater shrine to those killed in the attack. (Courtesy of MOHAI, Neg # 220)

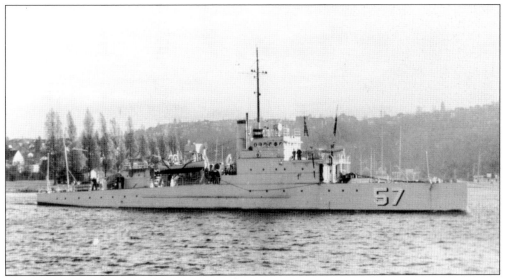

Eagle boats were mass-produced by the Ford Motor Company in World War I and famous for their ungainly square, flat surfaces. Seattle's own *Eagle 57* is shown here on Portage Bay. She earned the nickname "Pickle Boat" from the "Heinz 57 Varieties" advertisements. Between the wars she served successfully as a 13th Naval District training ship and as a unit of the Puget Sound anti-submarine patrol. She was moored on Lake Union and during the 1930s was the unofficial flagship of the Seattle Sea Scout fleet. (Courtesy of MOHAI Neg. No. 817)

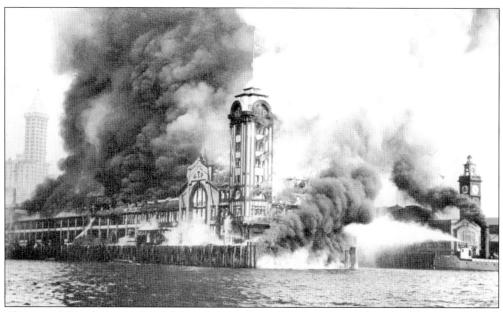

The Grand Trunk Pacific Dock located at the foot of Marion Street, Seattle, (see cover photo) was totally lost to a spectacular fire on July 30, 1914. Four people died and scores were injured in the fire. Many businesses were destroyed in the inferno, including the office of Ted Geary, a prominent northwest naval architect. As reported in the *Seattle Daily Times:* "Fearing that Geary might be trapped by the flames, his friend Hugh Chilberg sprinted to the burning dock and rushed through the entrance. He had hardly passed through the door when Geary appeared out of the smoke, pursued by tongues of flame. He had his hat in one hand and his coat in the other. 'Come on Ted,' shouted Chilberg. 'Beat it, yourself,' yelled Geary as he raced ahead of the flames. The pair had hardly gained the street when the whole structure was ablaze." Geary lost everything in the fire, including the plans of his famous racing yacht *Sir Tom*. (Courtesy of MSCUA, Univ. of Washington, Asahel Curtis Photo Co. Neg. No. 482)

L.E. "Ted" Geary is perhaps the best yacht designer in Seattle history. Born in Atcheson, Kansas, in 1885, Geary moved with his family to Seattle in 1892. Between 1899 and 1930, Geary established an outstanding record as a racing skipper with his designs of *Empress I, Empress II, Spirit, Spirit II,* and the legendary R-Class sloop, *Sir Tom*. Upon graduation from MIT in 1910, the designer returned to Seattle to formally establish his practice. Early work included the *Chickamauga* (1915), the first diesel-powered tugboat in America. In 1930, following a year as Commodore at Seattle Yacht Club, Geary moved his business to Los Angeles where he supervised the building of the *Thea Foss* (ex-*Infanta*) at Craig Shipbuilding. Following successful racing with the R-Class *Pirate*, he was named Southern California Skipper of the Year in 1935. Monuments to his creative genius are the fine motor yachts *Malibu, Blue Peter, Canim, Principia, Electra,* and *Mariner* (ex-*Sueja III*). Geary died in 1960. (Courtesy of PSMHS photo collection)

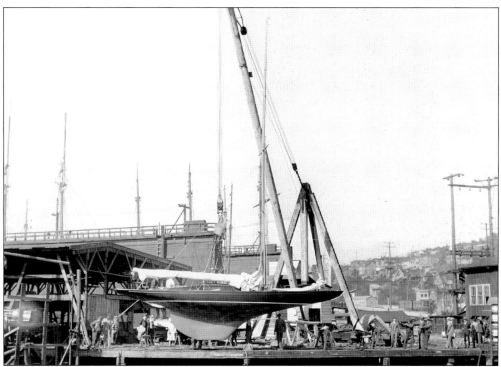

Before World War II, the Lake Union Drydock Co. built a number of quality yachts and pleasure boats at their yard on Fairview Avenue. On a sunny morning in early April, 1926, a party gathered there to launch the R Class sloop *Pirate*. Owned by Thomas S. Lee of Los Angeles, the boat was christened by his cousin, Virginia Merrill. Miss Merrill can be seen just aft of the rudder with the champagne bottle in her hand. L.E. "Ted" Geary designed *Pirate*. (Courtesy of MOHAI, PEMCO Webster & Stevens Collection, Neg. No. 83.10.12.357.1)

Construction and deck plan of R-Class Sloop *Pirate*. (Courtesy of PSMHS, Plans Collection)

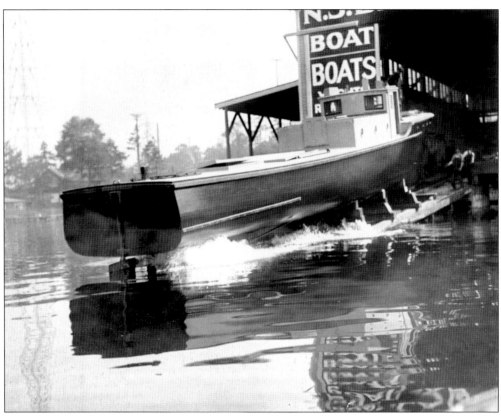

The fleet of local rum runners, referred to as "fast freighters," were active until the repeal by prohibition laws. The twin-screw, 65-footer shown here is an example of this class of vessel. Designed by Leigh H. Coolidge, she was launched in 1925 at the N.J. Blanchard Boatyard. (Courtesy of PSMHS, Neg. No. 89.89.270, Plans Collection)

This design, No. 505, and a number of other Coolidge rum runners are conserved in the PSMHS ships drawings collection. (Courtesy of PSMHS, Plans Collection)

Gwendolyn II is shown sailing off shore of Magnolia under full sail. The 48-foot *Gwendolyn* won numerous races on Puget Sound and Lake Washington during the 1920s and 1930s. (Courtesy of PSMHS collection)

Catalyst was an oceanographic research vessel for the University of Washington. She was built at Lake Union Drydock and Machine Works in 1932 and equipped with a Seattle-built Washington Estep diesel engine. She was based on Portage Bay but spent her summers at the University's laboratory at Friday Harbor on San Juan Island. She served the Coast Guard in World War II and still survives as a live-aboard yacht. (Courtesy of MOHAI Neg. No. 455)

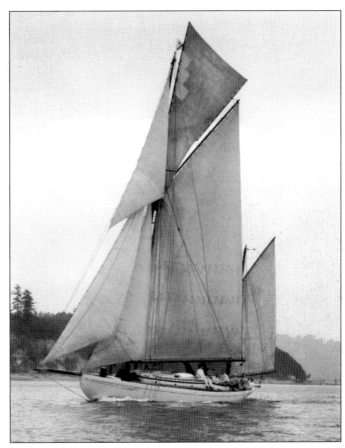

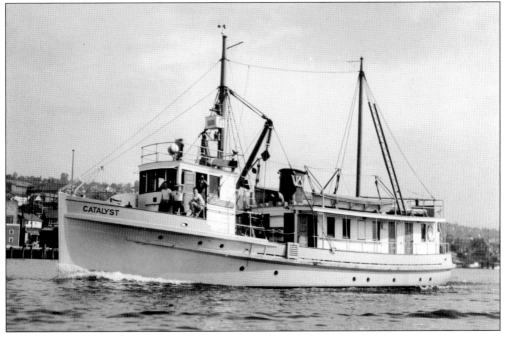

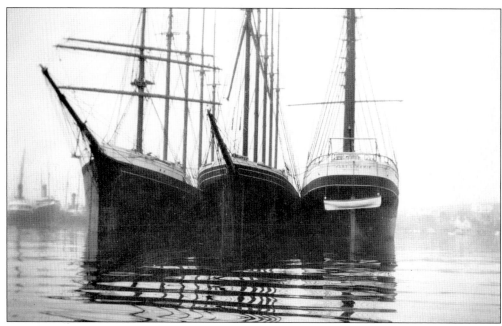

These three Nelson Steamship Company sailing ships lay idle in Lake Union from 1928 till 1934 after which these World War I vintage lumber carriers were scrapped and sold for hulks. From left to right, are the five-masted barkentine *Monitor*, five-masted schooner *Thistle*, and five-masted schooner *Fort Laramie*. (Courtesy of Harold Huycke, photo by Gordon Jones)

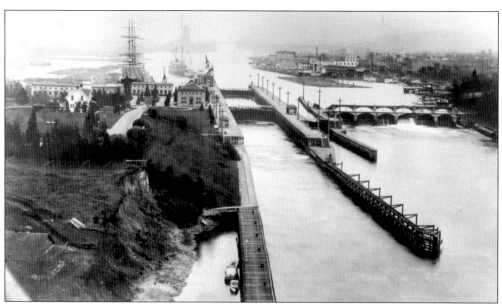

A 1939 view of the completed locks looking towards Salmon Bay. The large lock is on the left, the small lock in the center, the dam and spillway on the right. Vessels on the upstream side are the sailing ship *St. Paul* on the left behind the buildings, the Bureau of Indian Affairs supply ship *North Star* against the wing wall and the Lightship *Relief* at the Lighthouse Service Depot behind the log boom. Through the haze can be seen the Seattle Cedar Mill and the Ballard Bridge. (Courtesy of National Archives, RG77, Seattle)

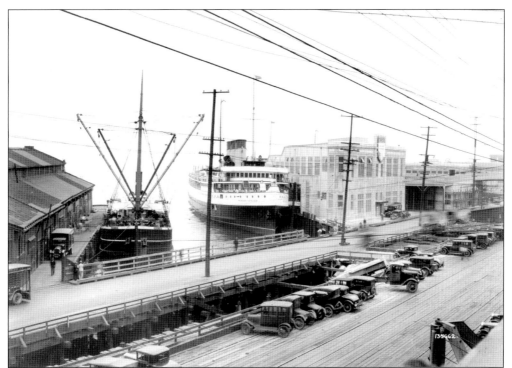

For many years Canadian Pacific Railway operated ships between Seattle and British Columbia points. Its ships were nearly always named for a royal prince or princess. In this early 1930s view the *Princess Kathleen* waits at the B.C. Steamship Company pier near Lenora Street. (Courtesy of MOHAI Neg. No. 83.10.41771.1)

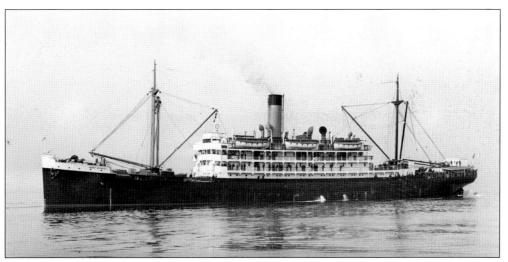

S.S. *Mount McKinley* was acquired by Alaska Steamship Company in 1936 from Grace Line. She was built in 1917 as *Santa Ana* and renamed *Mount McKinley* by Alaska Steamship Company. *Santa Elisa*, built in 1919, was also purchased by Alaska Steam from Grace Line and renamed *Baranof*. The two ships were very similar in most respects. *Mount McKinley* stranded on Scotch Cap reef March 18, 1942, with no injuries to passengers or cargo. However, before the ship could be refloated, storms and surf made her a total wreck. (Courtesy of Clint Betz)

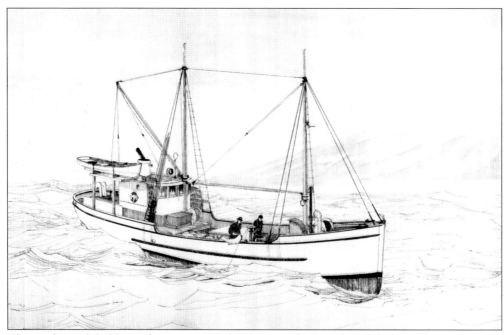

The traditional halibut schooners started fishing with dories as did the sailing schooners themselves in the early 1920s. A number of the schooners are still fishing after more than 85 years. (Pen and ink drawings of fishing vessels by James A. Cole, furnished by the William E. Hough Family)

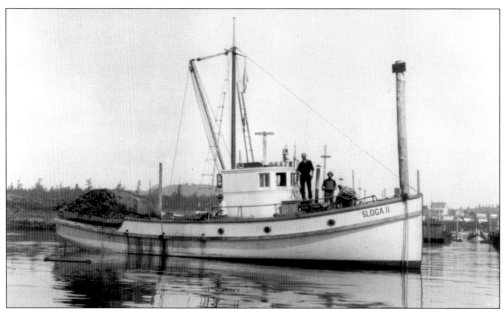

The curve of *Sloga II*'s 45-foot sheer line and curved bow show off her Scandinavian ancestry. As a seiner, she was short by later standards but since everything was performed manually, still required an eight-man crew. Note the seine net piled on the turntable on her stern. The wheel on the front of the pilothouse allows the skipper better visibility while setting his net. (Courtesy of John C. Illman)

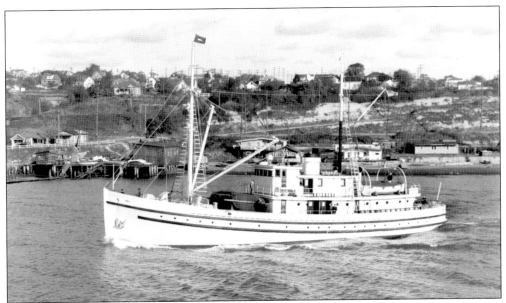

Penguin was a patrol and supply vessel used in connection with seal hunting in the Pribilof Islands in the Bering Sea. Although jointly sponsored by Canada, Japan, and the United States, she was managed by the US Bureau of Fisheries of the Department of Commerce. She was a twin screw, wood motor vessel built in 1937 by Ballard Maine Railway and spent her winters moored on Lake Union. (Courtesy of PSMHS, Neg. No. 1906)

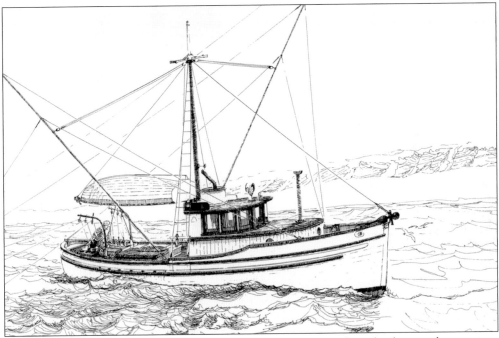

The trollers of the West Coast have evolved since about 1906 when the first gasoline engines were put in the primitive hulls of the time. Trolling is done by towing six or more weighted lines that have lures on hooks. (Pen and ink drawings of fishing vessels, by James A. Cole are furnished by the William E. Hough Family)

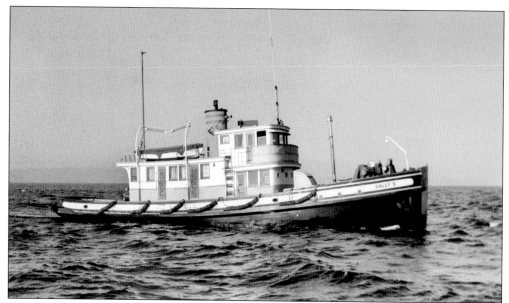

The 70-foot long *Sally S*, typical of the smaller diesel-powered tugs on Puget Sound used to tow logs, was built at Port Blakely in 1927. In 1965 her owner, Robert Shrewsbury Sr., sold her to Washington Tug & Barge Co. of Seattle. (Courtesy of PSMHS, Neg. No. 5708)

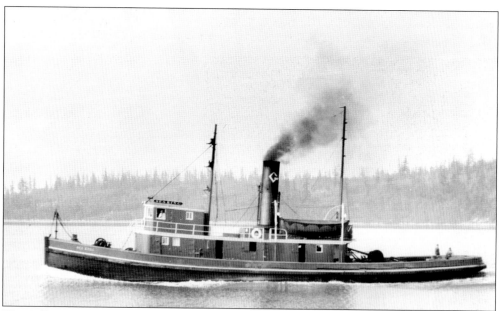

The Gilkey Brothers of Anacortes purchased the 119-foot steam tug *Sea King* in the early 1920s. She later became a unit of the Puget Sound Tug & Barge fleet with the merger of Cary-Davis, Drummond Lighterage, Pacific Tow Boat Co., and Gilkey Brothers in 1929. Although nearly 40 years old when originally purchased by Gilkey, she saw extensive service on Puget Sound and in the Strait of Juan de Fuca for the next 20 years. Her one claim to notoriety occurred in the 1930s when motion picture prop people disguised her as the tug *Firefly*, antagonist to the tug *Narcissus*, during the filming of the motion picture "Tugboat Annie," one of the most popular maritime films produced during the 1930s on Puget Sound. (Courtesy of PSMHS, Neg. No. 2286)

Pictured here in Elliott Bay is the famous steam tug *Wanderer*, one of the original Puget Sound Tug Boat Co. fleet, and one of the last active steam tugs in the Northwest. She was built by the Hall Brothers shipbuilders at Port Blakely, and launched on April 5, 1890, for the Port Blakely Mill Company. Her early career was spent towing windjammers from Cape Flattery on the Pacific Coast to Puget Sound. Over the years the *Wanderer* worked for several companies, including the shipbuilding firm of Skinner & Eddy Corporation, Seattle, and the Merrill & Ring Lumber

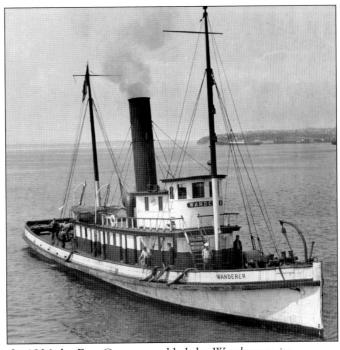

Company for log-boom towing. In 1936 the Foss Company added the *Wanderer* to its collection of tugs. The venerable *Wanderer* played a big part in the shipping activities of Puget Sound for more than a half century. (Courtesy of PSMHS, Neg. No. 2678)

L. Henry Foss, 1891–1986, was the third son of the founders of the famous "Foss Launch and Tug Company." Henry Foss became the primary builder of the Tacoma fleet and tug operation of this company. His World War II service in the Pacific was invaluable in the tug and towing work for the U.S. Navy. He retired with the rank of Rear Admiral. (Courtesy of Harold Huycke)

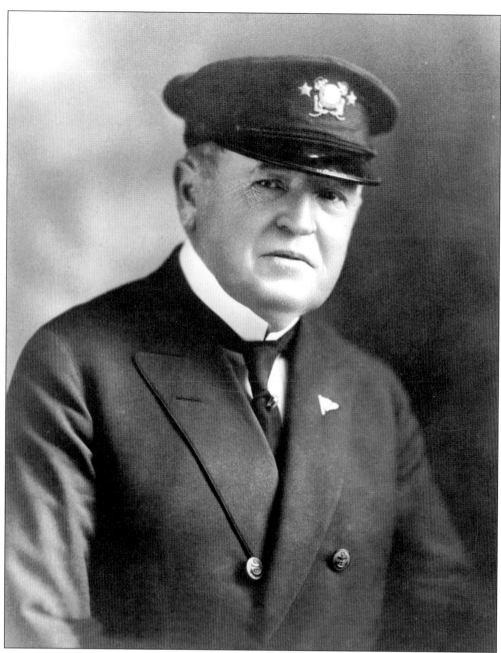

Captain James Griffiths came to the Puget Sound country from England with his wife and young son in 1885 when he was 24. He had worked in the maritime trade and was an energetic businessman. He formed a general shipping agency under the name of James Griffiths & Sons and was involved in tugboat operations, shipbuilding, and a steamship company. He was instrumental in forming an alliance between the Great Northern Railway and the NYK shipping company to extend transcontinental railroading by sea to the Orient in 1896. He died on June 29, 1943. (Courtesy of Washington State Historical Society Library)

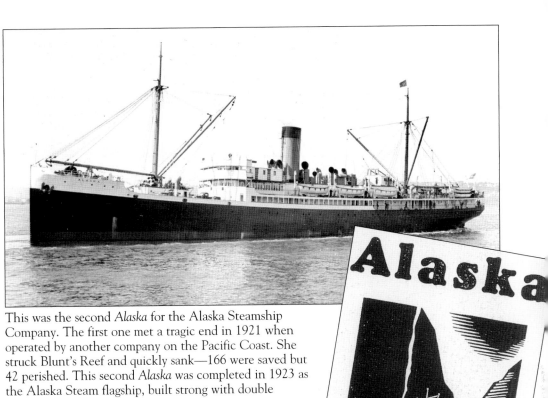

This was the second *Alaska* for the Alaska Steamship Company. The first one met a tragic end in 1921 when operated by another company on the Pacific Coast. She struck Blunt's Reef and quickly sank—166 were saved but 42 perished. This second *Alaska* was completed in 1923 as the Alaska Steam flagship, built strong with double bottoms, numerous watertight bulkheads, twin screws, and triple expansion engines. Alaska Steamship converted her to turbine-electric in 1931, making her the only electric drive steamer on the Pacific Coast at that time. She was sold to Northland Transportation in 1947 then to Margo-Pacific Lines in 1954 and renamed *Mazatlan*. She failed as a tropical cruise ship and ended up at the scrappers in Japan. (Courtesy of Clint Betz)

This advertisement portrays one of the trim white passenger liners *North Coast* and *North Sea* that operated for Northland Transportation Co. after World War II. Alaskans formed the company in 1927 to operate the small motor vessel *Norco* to serve canneries in Southeastern Alaska. In the 1930s, other investors added additional freight and passenger ships, most with the "North" prefix in their names. When private shipping returned after World War II, they operated one "Liberty," five "Knot" class motor vessels, and the two liners. By 1948, operating costs, strikes, and fierce competition forced the company's sale to Alaska Steamship Co. where the fleets and management were merged. (Courtesy of Ronald Burke advertisement collection)

Alaska

When Americans get the kinks of over four years of war out of their systems and return to normalcy thousands will no doubt want to see and enjoy Alaska, the wonderland of might and magnificence.

Then, too, we will have the kinks out of over four years of frantic wartime operations and be prepared to offer you again the most interesting, delightful and economical vacation trip on the face of the earth.

NORTHLAND
TRANSPORTATION CO.
Pier 56—Seattle

The steam schooner *Tongass* is shown here in Seattle Harbor. After years in the coastwise lumber and cargo trade, the steam schooner *Wapama* was sold by the Viking Steamship Company of San Francisco to the Alaska Transportation Company of Seattle, renamed *Tongass*, and was employed in cargo trade to Alaska until 1947. Later, *Tongass* was sold to the State of California for restoration as a museum ship in San Francisco under her original name *Wapama*. She is the last wooden steam schooner in existence. (Courtesy of Clint Betz)

This deck view is of the German steamer *Sesostris*, in approximately 1905–1910. This steamer was built in Flensburg in 1897, and was a member of the fleet of coal-carriers of the Kosmos Line of Hamburg. Note the features on deck, such as battened hatches, classic stock anchor at the stern and open, and emergency steering station at the extreme aft end of the main deck. (Courtesy of Harold Huycke)

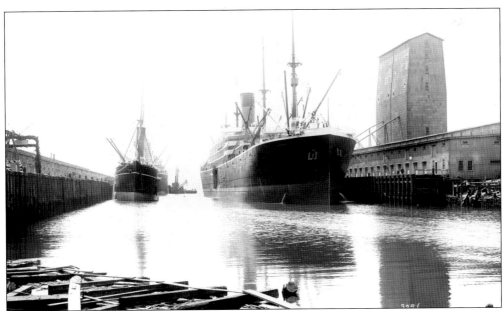

S.S. *Minnesota*, the largest cargo vessel in the American merchant marine when launched in 1904, is shown at the Great Northern docks at Smith Cove, currently filled industrial land. The *Minnesota* measured 630 feet in length, 72 feet in beam, and had a gross tonnage of 28,000. She had eleven decks and accommodated 50 first-class, 100 second class, and 1,000 steerage passengers. She was sold in 1915 to new owners on the East Coast. (Courtesy of MOHAI, PEMCO, Webster & Stevens Neg. No. 3296)

The Pacific Coast Company steamer *Curaçao* awaits cargo and passengers at a Seattle terminal. She was a steel-hulled steamer launched in 1895 from the Cramp's shipyard in Philadelphia, and measured 241 feet in length. In 1940 she became the Greek freighter *Helenic Skipper*, and on July 12, 1940, while sailing off Grays Harbor, went to the bottom of the Pacific Ocean as a result of fire and explosion. All the crew of 17 men were rescued. (Courtesy of PSMHS, Neg. No. 689-7)

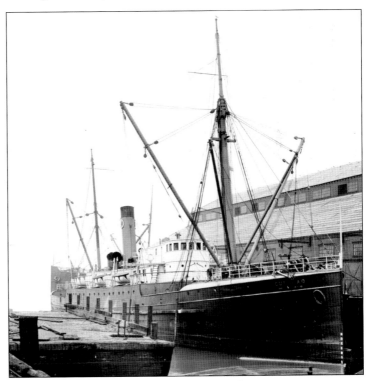

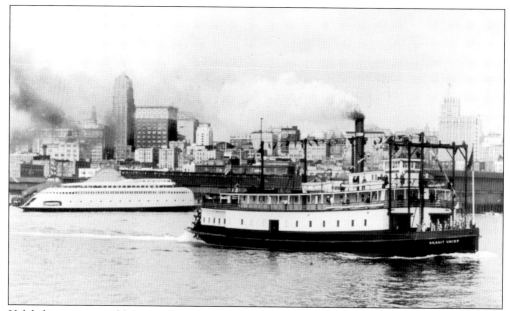

Kalakala was a new addition to Seattle's waterfront in 1938 when she was photographed passing behind the venerable *Skagit Chief*, a sternwheeler more often found on the Skagit River. (Courtesy of PSMHS, Lovejoy collection)

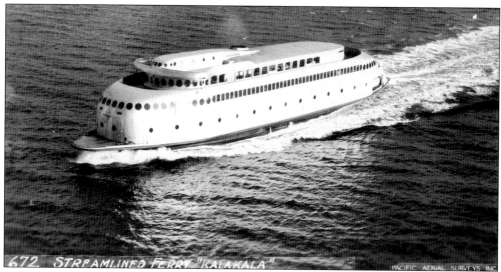

Kalakala started her long life in 1927 as the turbo-electric ferry *Peralta* on the San Francisco-Oakland route. Capt. Alex Peabody of Puget Sound Navigation Co. bought her burned-out hulk after a disastrous fire in 1933. She was towed to Puget Sound and two years later emerged as a silver-sheathed art-deco icon. Her new 3000 horsepower Busch-Sulzer engine had a legendary tendency to cause vibration when underway. Nevertheless, she was the pride of the fleet and enjoyed national publicity, featured on many postcards. Her years were spent on the Seattle-Bremerton run with running mates *Chippewa*, *Willapa*, and *Enetai*. In 1967, after several years of retirement, *Kalakala* was sold and converted into a crab-processing vessel for use at Kodiak, Alaska. In 1998, Peter Bevis rescued her from oblivion and brought her back to Seattle where she awaits major restoration as a museum attraction. (Courtesy of Mark Shorey)

Four

THE WAR YEARS:

PUGET SOUND AND SEATTLE GO TO WAR

The population of Seattle grew from 368,302 in 1940 to approximately 480,000 in 1943. People were hired to build airplanes, ships, tanks, and other materials as war production increased. The Navy bought the Smith Cove piers, the country's largest earth-filled piers, and established a major supply depot in March 1941. Naval training facilities were opened at the University of Washington and at the south end of Lake Union, presently the home of the Maritime Heritage Center. Shipbuilding expanded on Harbor Island, on Lake Washington, and in the Ship Canal. The Puget Sound Navy Yard at Bremerton, the Ammunition Depot at Bangor on Hood Canal, and the Sand Point Naval Air Station in Lake Washington were expanded greatly.

After Pearl Harbor, the U.S. Army leased Piers 36 through 39 to create a major Port of Embarkation. The Port of Seattle obtained the East Waterway Dock on Harbor Island, built a grain elevator at Hanford Street, and started construction of the Seattle-Tacoma airport midway between the two cities. Transportation to Alaska was constant as military facilities were built or improved. Used ferries were purchased in San Francisco and put into service in Puget Sound to serve the increased traffic to and from Bremerton and the Navy Yard.

Peace was welcome after the long and weary war, but changing from wartime to a peacetime economy was difficult. The warriors returned, ships were laid up and mariners beached, shipyards ran out of work, and demands for lumber products, coal, and minerals declined. The previously constant activity on the waterfront slowed to a crawl. Strikes and fare increases disrupted the ferry service provided by Puget Sound Navigation Company across the Sound. The voters of Washington approved the development of a state ferry system in the midst of a storm of politics and economics; the Washington State Ferry system started operation in June of 1951.

The Korean War, beginning in June 1950, caused considerable revival in shipping activities with Army and Navy cargo movements putting new demands on all port facilities and ship operations. This carried through the 1950s.

(*previous page*) The research vessel, *Brown Bear*, a wooden-hulled freighter built in 1934. She was acquired by the University of Washington, Dept. of Oceanography, in 1950 from the U.S. Fish and Wildlife Commission for use as a research ship. Length 114 feet, displacement 270 tons, she was returned to the Fish and Wildlife Commission in 1965. (Courtesy of the artist Hewitt Jackson)

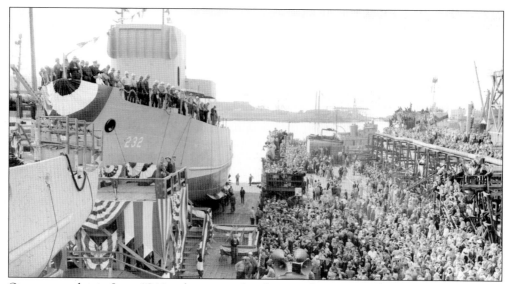

On a sunny day in June 1944, a large crowd gathers at the Puget Sound Bridge & Dredging Company yard for the launching of two new minesweepers, *Facility* and *Executive*. Puget Sound Bridge & Dredging Company built several river steamers for the Klondike gold rush and over 20 naval vessels for World War I. After building the pontoons for the first Lake Washington floating bridge, the company turned back to building ships for World War II. (Courtesy of MOHAI, *Seattle Post-Intelligencer* Collection, Neg. No. PI-26304)

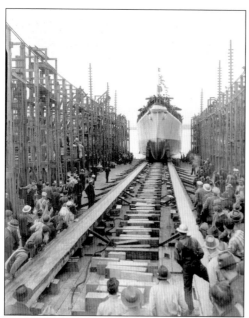

This photo, taken in May 1942, shows the launching of the seaplane tender *Chincoteague* at the Lake Washington Shipyards at Houghton, near *Kirkland*. The Lake Washington Shipyard built a number of seaplane tenders for service in the Pacific. These floating machine shops and parts warehouses serviced the seaplanes that the United States Navy used for reconnaissance and rescue. (Courtesy of MOHAI, *Seattle Post-Intelligencer* Collection, Neg. No. PI-26289)

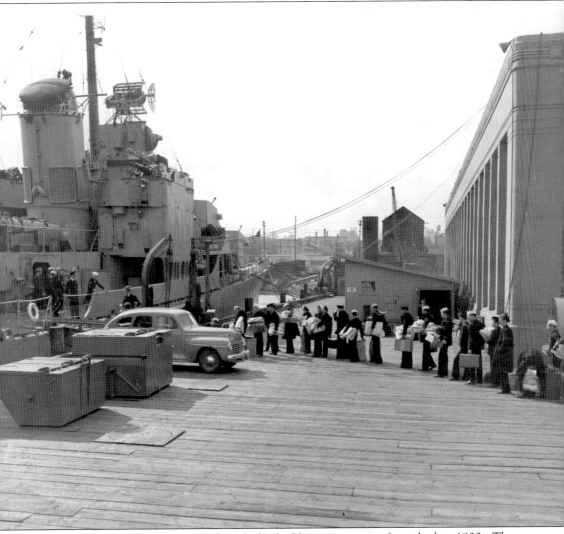

The Naval Reserve Center at the south end of Lake Union was active from the late 1930s. The Navy dedicated the Armory Building to the right on July 4, 1941. It is now home to the Maritime Heritage Foundation. The photo shows a group of reservists waiting to board a modified World War II destroyer for a training cruise. (Courtesy of NORPAC Navy)

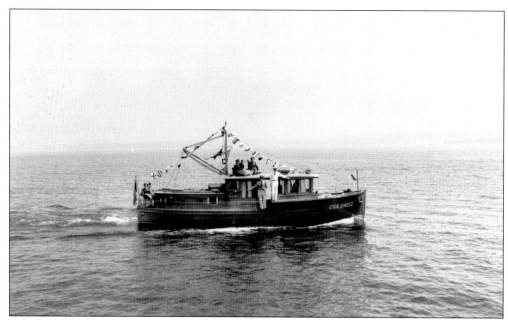

During the Second World War, restrictions were placed on pleasure boats and some were pressed into military service. Navigation on Puget Sound waters was prohibited after dark, and vessel registration numbers were required on the bows in foot-high numerals. In her wartime trim, the bridge deck cruiser *Victoria* has "dressed ship" for an outing. (Courtesy of PSMHS, Neg. No. 3544-20)

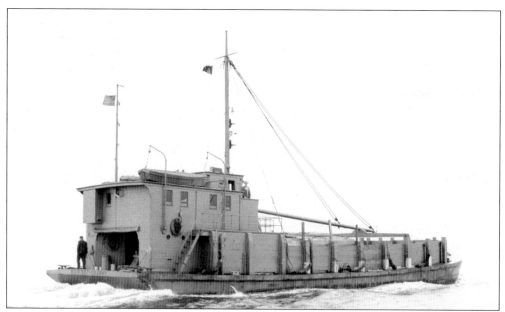

B.S.P. 507, shown here, is a power scow built for the Army during World War II. She was designed by H.C. Hanson, a noted naval architect in Seattle. The scows were built to supply outposts on the Alaskan Coast during the war. After the war many of these scows were converted and made excellent cannery tenders in the Alaskan fish trade. (Courtesy of MOHAI, Neg. No. 3467-1P)

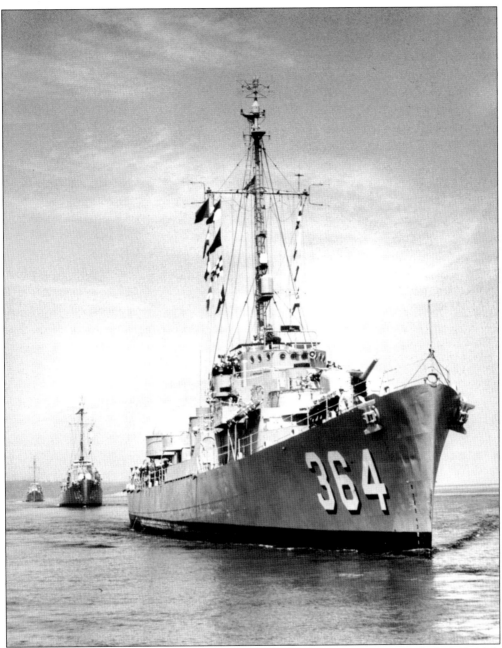

This trio of World War II destroyer escorts served in the Pacific: USS *Rombach* (DE 364), *Brannon* (DE 446), and *Whitehurst* (DE 634). *Whitehurst* sank a Japanese submarine in September 1944 but was later hit by a Kamikaze plane that took the lives of 42 of her crew. After the war the Navy permitted her use in filming the movie "Enemy Below." All three served as reserve training ships after the war and were stationed in Seattle. (Courtesy of NOjRPAC Navy)

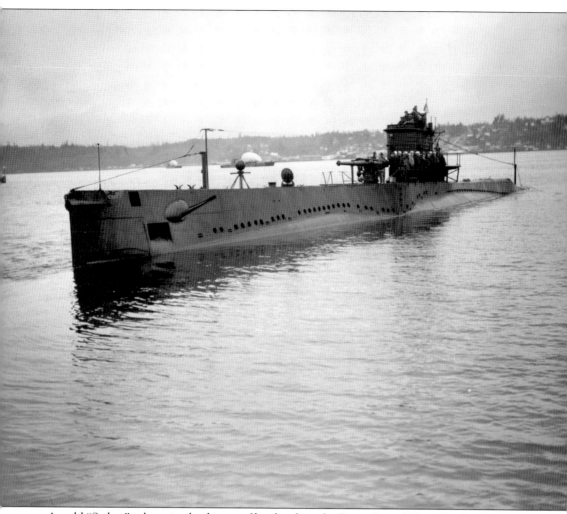

An old "S class" submarine backs out of her berth at the Puget Sound Navy Yard in Bremerton. The "S. Boats" were built from 1920 to 1924 and, during World War II, were mostly used in the Aluetian Campaign. Note the barrage balloons on the barges anchored in the background. After the war, reservists were trained on submarines like the *U.S.S. Puffer* (268), moored at the Naval Reserve Center on Lake Union. (Courtesy of NORPAC on Lake Union)

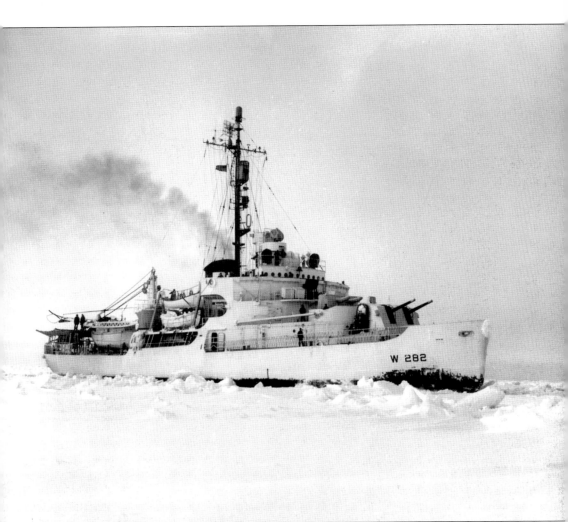

Coast Guard Cutter *Northwind* was built during World War II to the design of the Swedish icebreaker *Ymer*. A twin screw vessel with diesel electric machinery, she had a retractable bow propeller. The federal government loaned her to Russia during the war, who returned the *Northwind* after the end of hostilities for stationing in Seattle. She participated in "Operation Hi-Jump," the first Antarctic expedition after the war, and made many voyages there in later years. (Courtesy of Coast Guard Museum, Northwest No. 91.83/2)

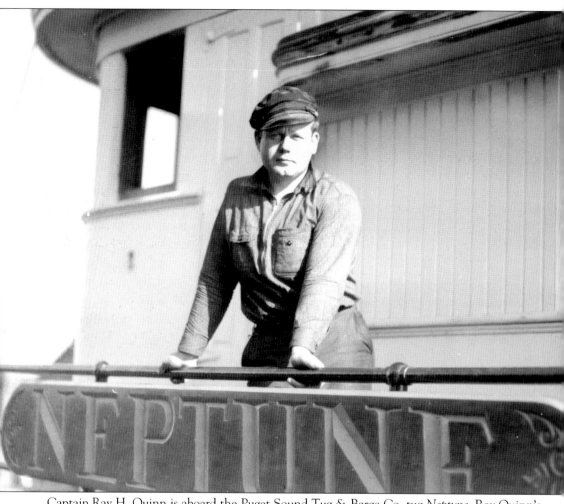

Captain Ray H. Quinn is aboard the Puget Sound Tug & Barge Co. tug *Neptune*. Ray Quinn's maritime career began in 1923 at the age of 15 on board the Cary-Davis tug *Christie R.* Advancing quickly, he became temporary master of the old tug *Equator* by the time he was 18 years old and got his first command, the Cary-Davis tug *Dolly C*, when he was 19 years old. Through the years, he commanded many vessels for Cary-Davis, Puget Sound Tug & Barge, and the Foss Company, including the venerable tugs *Douglas* and *Wanderer*, and became first captain of *Neptune* in 1938. During the initial years of World War II, Captain Quinn spent extensive time towing barges containing supplies for the U.S. Army in Alaskan waters. Late in 1943, he decided to obtain his master mariner's ocean unlimited tonnage license. He then went around the world as Chief Mate on two Victory ships returning to the United States in 1946. In 1954, Captain Quinn joined the Puget Sound Pilots and served in that capacity for 20 years, completing a maritime career spanning more than half a century. Many of Captain Quinn's adventures appear in the pages of *The Sea Chest*. (Courtesy of PSMHS)

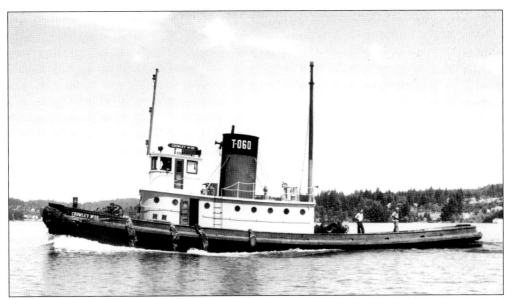

The diesel-powered tug *Crowley No. 28*, later renamed *Tyee*, became a unit of the Puget Sound Tug & Barge Co. fleet in 1942. Originally built at Alameda in 1927 for Crowley Launch & Tugboat Co., Crowley operated her in California waters for her first 15 years of service. Hal Will, longtime member of PSMHS and former editor of *The Sea Chest*, was on board the 80-foot long vessel when Joe Williamson took this photograph in 1943. Will writes: "*Crowley No. 28* became my favorite during the summer of 1943. I am farthest aft on the back deck wearing dungarees and sailor cap, as always. I had to dash to Joe Williamson's Marine Salon at the first opportunity after we saw our photo being taken by him on the *Photo Queen*." (Courtesy of PSMHS, Neg. No. 192-1)

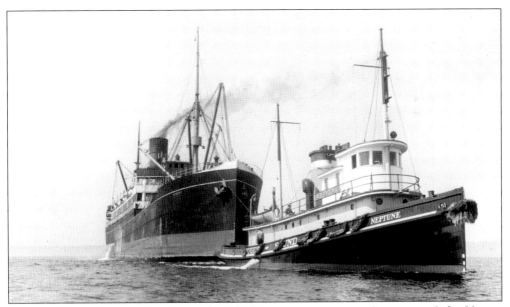

The ocean-going tug *Neptune* tows the Alaska cannery transport *Otsego* into Lake Union, Seattle, destined for the Libby, McNeil & Libby Dock. *Otsego* was eventually sent to Russia as part of the World War II Lend-Lease program. (Courtesy of PSMHS, Neg. No. 1698-19).

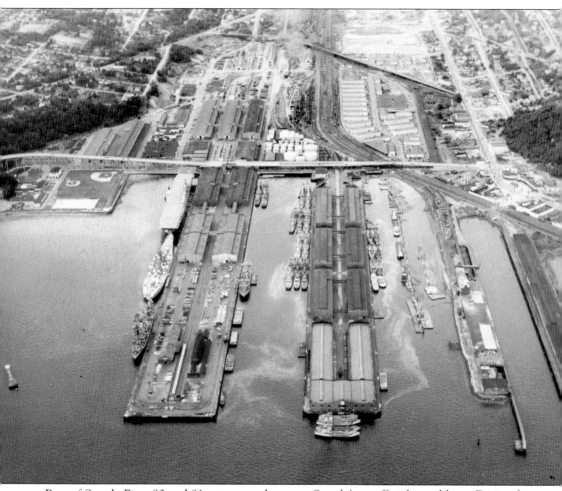

Port of Seattle Piers 90 and 91 once were home to Seattle's unofficial naval base. Dating from 1905, the Navy acquired the site in 1942 making it the 13th Naval District Operating Annex (NOA). Note the large assemblage of warehouses, shops, barracks, fuel tanks, and the Great Northern railroad yard. This photo taken in 1947 or 1948 shows a number of mothballed ships including a battleship and aircraft carrier. Two active cargo ships appear to be moored at the pier on the left. The oil slicks reveal a casual approach to environmental awareness. (Courtesy of Hal Will)

(*opposite, bottom*) The ocean-going diesel tug *Hercules* (Ex-Army tug *LT 463*) hauled out for repairs. This World War II-vintage vessel had the unique distinction of having moved faster astern than ships of the Mikimiki class were designed to go forward. In 1947, this 126-foot unit of the Puget Sound Tug & Barge Co. fleet and her sister ship *Monarch* (formerly *LT 466*) were chartered to tow the badly-damaged survivor of the Pearl Harbor attack, the battleship USS *Oklahoma*, from the Hawaiian Islands to Oakland, California, for scrapping. When about 535 miles east of Pearl Harbor, *Oklahoma* developed a heavy list and capsized. Although the captains of the two tugs had the foresight to previously unshackle the cable ends of the 1400-foot towline connecting the hulk to the two tugs, the sinking battleship dragged the tugs astern at a rate of 15 to 30 knots, stopped their engines, and nearly dragged them under before they broke free of the sinking battleship's grasp, thus averting a tragedy that could easily have been a three-vessel sinking with no survivors. (Courtesy of PSMHS, Neg. No. 2931-22)

Ship repair work has always been a thriving business throughout Seattle shipyards. Here we see a ship's caulker repairing the hull of a boat in 1940. With a caulking iron, he is driving cotton into the seams of a ship's planking in order to render them watertight. Note the cotton wrapped around his left arm and fed by the iron in his hand. After the cotton is driven in hard, the gap between the planks is filled with a composition to prevent the cotton from rotting through contact with water. Caulking is a highly specialized trade in the shipbuilding industry and requires a significant degree of dexterity and skill. (Courtesy of MSCUSA, University of Washington, Neg. No. UW5803)

The Canadian Pacific Railway's *Princess Marguerite* made a dramatic sight along Alaskan Way. Here she is shown loading passengers at the Port of Seattle/CPR dock for the voyage to Canada in the 1950s. (Courtesy of Hal Will)

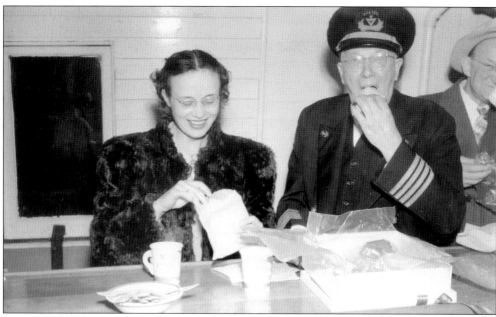

Captain Mary Parker Converse, shown here aboard ship with Captain Howell Parker, skipper of *Virginia V*, was the first woman to be commissioned in the Merchant Marine after attending the American Merchant Marine Academy at King's Point, New York. She was a student at Kildall's Navigation School in Seattle in 1941 in preparation for her Unlimited Master's license. At age 68 she became the first woman to earn captain's papers in the U.S. Merchant Marine. The vessels on which she served include *Henry S. Grove*, *Lewis Luckenback*, and *F.J. Luckenback*. (Courtesy of PSMHS photo collection)

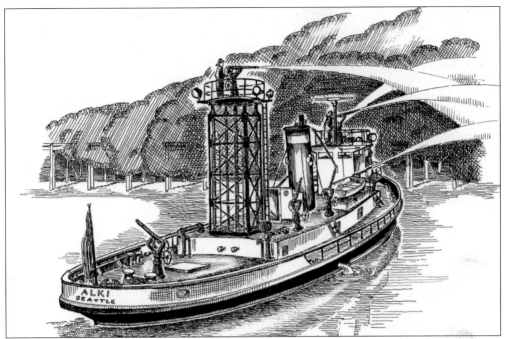

Seattle's fireboat *Alki*, built in 1927, was twin screw with gasoline engines. As well as being able to pump 12,000 gallons per minute, she had the advantage of having a monitor mounted on a tower 32 feet above the waterline that could be telescoped up an additional 10 feet. She joined *Duwamish* in fighting several stubborn fires at Todd Shipyard. *Alki* was converted to diesel in 1947 and is still in standby status. (Courtesy of the Fletcher family, drawing by Ronald R. Burke)

Chippewa was originally built in 1900 on the Great Lakes as a passenger and freight steamer. Like many early steamers, she survived for many years in a variety of guises, first being converted to a car ferry, and then re-powered with diesel in 1932. In mid-century *Chippewa* was perhaps the best-known ferry boat on the Seattle-Bremerton run, looking very much like the familiar boats of today. (Courtesy of Ron Burke original drawing)

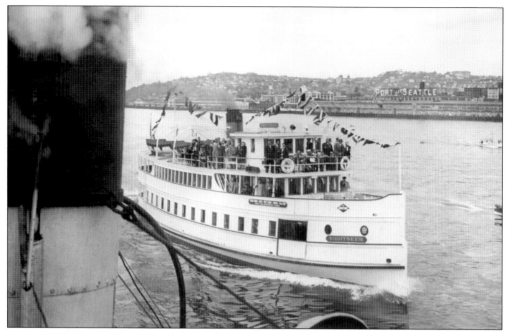

On Maritime Day in 1948 *Virginia V* and *Sightseer* raced the length of Elliott Bay. This view shows *Sightseer* as *Virginia V* pulls ahead. In the background can be seen the Port of Seattle sign on Pier 66, a fixture of the waterfront for decades until the 1980s. (Courtesy of PSMHS, Lovejoy collection)

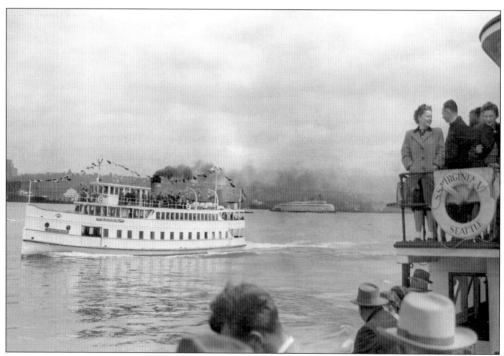

Following the conclusion of the race, *Virginia V* and *Sightseer* steam north across Elliott Bay. In the distance can be seen *Kalakala*. (Courtesy of PSMHS, Lovejoy collection)

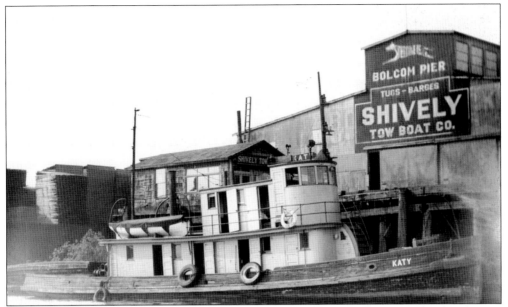

The tug *Katy* moored at the Shively Tow Boat Co. dock on Lake Washington Ship Canal about 1947. The 80-foot long tug *Katy* was constructed for the Coast & Geodetic Survey as a steamer at San Francisco in 1868. In 1885 she was sold to new owners and converted to a tug service to Alaska. In 1910, she became the first vessel in the Chesley Towing Company at Seattle. Captain Otis Shively purchased *Katy* in the late 1920s. In 1952 she was burned on a beach north of Edmonds. (Courtesy of PSMHS, Neg. No. 1317)

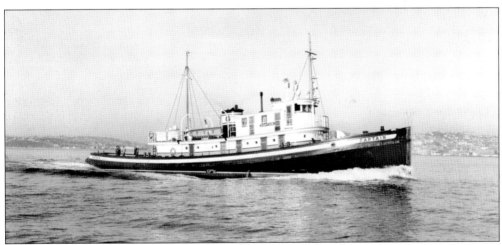

The Mikimiki-class diesel tug *Captain*, formerly Army Transport Service (A.T.S.) *LT 518*, was one of a large fleet of tugs built by the government for World War II service. This class of vessel, designated as LT (large tug), was originally designed in 1929 by Seattle naval architect, L.H. Coolidge. Due to a critical shortage of ocean-going tugs to tow barges during the war, the government slightly modified Coolidge's original design to build a fleet of similar tugs on the East and West coasts. The government eventually surplused *LT 518*, selling the 126-foot vessel to Washington Tug & Barge Co. in 1958. Her new owners used her initially to tow their 268-foot steel barge *Griffnip* between Puget Sound and Alaska ports. She also saw service to the Far East during the Vietnam War. (Courtesy of PSMHS, Neg. No. 5806-19)

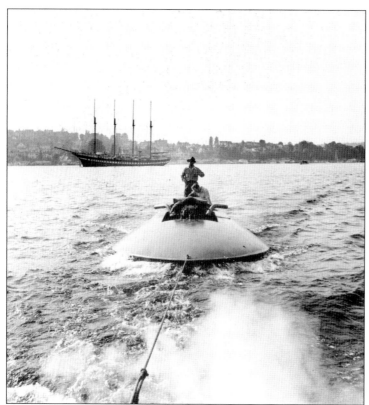

The *Slo-Mo-Shun IV*, the most revolutionary hydroplane of the 20th Century, was designed and built in Seattle at the Jensen Motorboat Co. on Portage Bay. Here she makes her maiden voyage on October 1, 1949. Aboard for the tow out to the lake were the owner Stan Sayers, designer/racer Ted Jones, and designer/builder Anchor Jensen. The Guiness yacht *Fantome* is shown in the background in Portage Bay. (Courtesy of photographer Mary Randlett©)

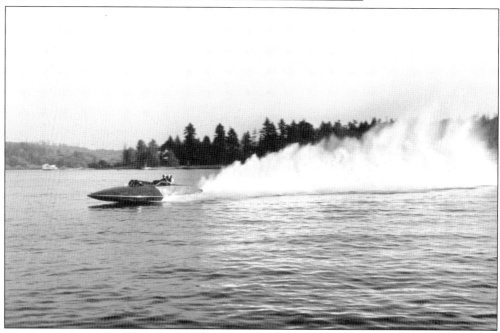

Conditions on the lake were ideal for this run off of Evergreen Point. *Slo-Mo-Shun IV* was much stripped down from her later racing trim and reached speeds estimated in excess of 130 mph. (Courtesy of photographer Mary Randlett©)

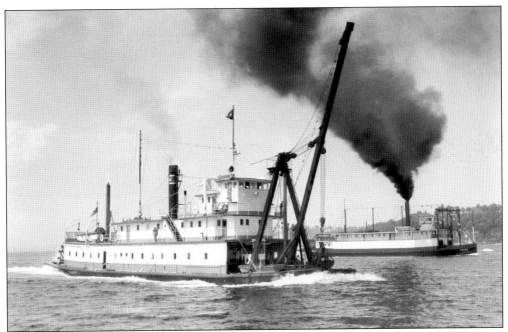

W.T. Preston was a snagboat for the Seattle District of the U.S. Army Corps of Engineers. Sternwheel steamboats once provided essential transportation on Puget Sound area rivers. The Corps had the responsibility of keeping those rivers and other waterways clear of sunken stumps, logs, and floating debris. *Preston* and two predecessors provided this service from 1883 to 1981. The photo shows her racing the Skagit River steamboat *Skagit Belle* in 1950. (Courtesy of PSMHS, Neg. No. 4740)

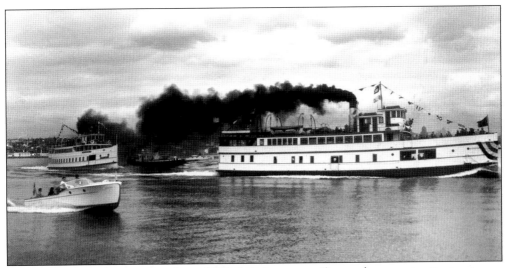

In March 1948, the five founders of PSMHS (see page 4) saw the opportunity to stage a steamboat race on Elliott Bay to celebrate National Maritime Day and World Trade week, so this became the first major project for the Society. The race got under way on May 22 at 2:00 p.m. with Captain Harry Wilson commanding the luxurious *Sightseer*, and Captain Howell Parker at the wheel of *Virginia V*. The race was surprisingly close. Over the five-mile course, *Virginia V* won by only three-quarters of a length. (Courtesy of PSMHS, Neg. No. 3956-7)

The Montlake Cut on the Lake Washington Ship Canal is the site of the annual Opening Day Parade held at the beginning of the boating season. This Joe Williamson photo, taken from north approach to the Montlake Bridge, shows the sailboat fleet at the 1956 event. The famous yawl *Dorade* can be seen just right of center, the John Alden-designed sloop *Angelica* left center. (Courtesy of PSMHS, Neg. 3544-244)

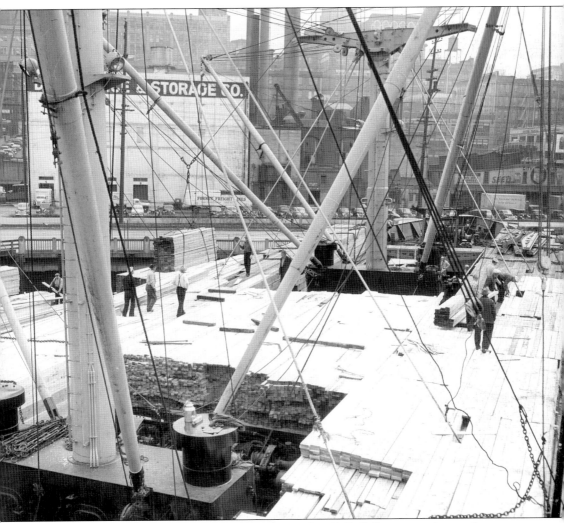

The Weyerhaeuser Steamship Company's Liberty ship *F.S. Bell* is moored to a downtown Seattle wharf, with lumber scows alongside and loading lumber in the early 1950s. Before the inevitable advent of packaged lumber and fork-lift stowage, lumber cargoes on coastwise steam schooners and intercoastal freighters were stowed by hand, piece by piece. The end result was a much tighter stow and a bigger load, but far more time was required for loading and discharging. (Courtesy of Harold Huycke)

Power scows were built during World War II to supply the small outposts on the Alaskan Coast, which did not usually have docks or piers. These stoutly built vessels were able to go onto the beaches to unload supplies, making them ideal for operating in the rivers of Alaska during the herring and salmon runs. (Pen and ink drawings of fishing vessels by James A. Cole, furnished by the William E. Hough Family)

Most of the vintage cannery tenders are gone. Many of them were handsome vessels of house-aft or house-forward design and their equipment consisted of a mast, boom, and a brail net for unloading from the catcher boats. (Pen and ink drawings of fishing vessels by James A. Cole, furnished by the William E. Hough Family)

Puget Sound gillnetters are not restricted to 32 ft. in length as are the Bristol Bay gillnetters, but most of them are less than 32 ft. in length. The house-aft design, (known as the Columbia River bow picker type) enables the net to be set and retrieved over the bow and away from the boat's propeller. (Pen and ink drawings of fishing vessels by James A. Cole, furnished by the William E. Hough Family)

Bristol Bay gillnetters have always been restricted to a length of 32 ft. When they became powered vessels in 1951 they began to evolve into a variety of configurations, in spite of this. (Pen and ink drawings of fishing vessels by James A. Cole, furnished by the William E. Hough Family)

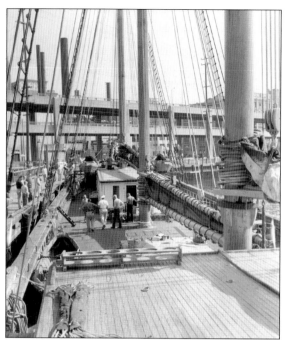

C.A. *Thayer* was moored to a pier on the Seattle waterfront in September 1957. This historic three-masted schooner, dating from 1895, was originally built for the Pacific Coast lumber trade and after 1925 was sometimes laid up. She eventually spent the post-World War II years in the Bering Sea codfish trade. After her last voyage in 1950, she was laid up and eventually sold to the State of California, Division of Beaches and Parks, and sailed from Seattle to San Francisco. Shown here with sails bent and a crew on board ready for the tow to Cape Flattery and her last voyage under sail. (Courtesy of Harold Huycke, photo by Joe Williamson)

The schooner C.A. *Thayer* spent about two months in repairs at a Seattle shipyard in 1957. The final repairs included caulking the new sections of deck in the traditional manner that has changed very little from centuries past. The procedure was to first drive into the V seams one or more strands of caulking cotton, followed by one or more strands of oakum, and payed with Stockholm tar. (Courtesy of Harold Huycke)

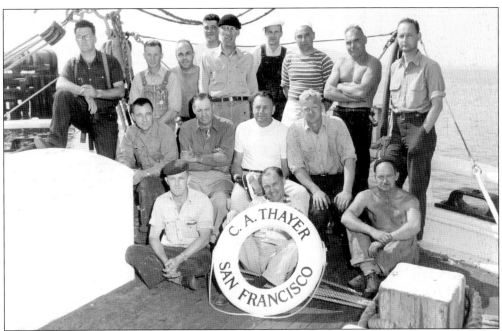

The C.A. *Thayer* crew in Seattle in September 1957 had a mixture of San Francisco, Seattle, and Tacoma volunteers. The schooner was more than adequately manned with a crew of experienced craftsmen and sail-trained seamen. They were paid $1.00 for the coastwise voyage which lasted two weeks. The crew, from left to right, was: (top row) Karl Kortum, Fred Fischer, Gordon Fountain, Roderick Norton, Axel Widerstrom, Gordon Jones, Clark Turner, John Davies, and Gordon Riehl; (middle row, seated) Harry Dring, Jack Dickerhoff, Captain Adrian F. Raynaud, and Johnnie Gruelund; (front row, seated) Harold Huycke, Philip Luther, and Donn Shannon. (Courtesy of Harold Huycke, photo by Joe Williamson)

Paul Kauffman provided a magnetic compass for the schooner C.A. *Thayer*, on loan, for the ship's last voyage from Seattle to San Francisco, 1957. Mr. Kauffman had been a compass adjustor and nautical instrument expert in Seattle since the turn of the century. Captain Adrian Raynaud observes the placement of the compass away from the iron steering wheel. (Courtesy of Harold Huycke.)

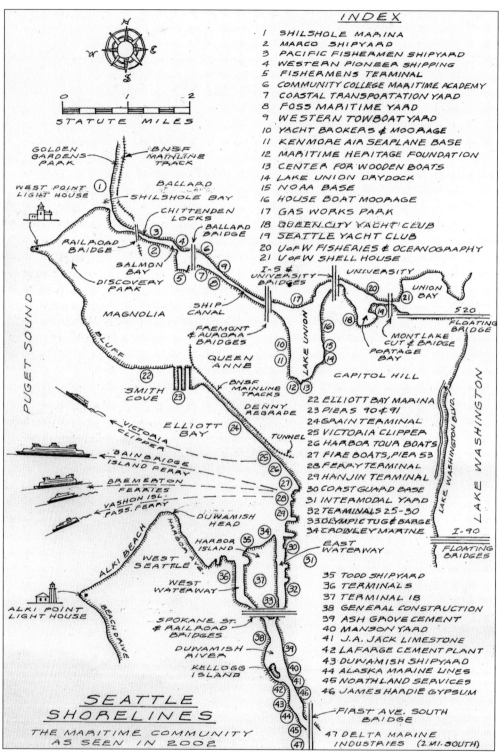

INDEX

1 SHILSHOLE MARINA
2 MARCO SHIPYARD
3 PACIFIC FISHERMEN SHIPYARD
4 WESTERN PIONEER SHIPPING
5 FISHERMENS TERMINAL
6 COMMUNITY COLLEGE MARITIME ACADEMY
7 COASTAL TRANSPORTATION YARD
8 FOSS MARITIME YARD
9 WESTERN TOWBOAT YARD
10 YACHT BROKERS & MOORAGE
11 KENMORE AIR SEAPLANE BASE
12 MARITIME HERITAGE FOUNDATION
13 CENTER FOR WOODEN BOATS
14 LAKE UNION DRYDOCK
15 NOAA BASE
16 HOUSE BOAT MOORAGE
17 GAS WORKS PARK
18 QUEEN CITY YACHT CLUB
19 SEATTLE YACHT CLUB
20 U of W FISHERIES & OCEANOGRAPHY
21 U of W SHELL HOUSE

22 ELLIOTT BAY MARINA
23 PIERS 90 & 91
24 GRAIN TERMINAL
25 VICTORIA CLIPPER
26 HARBOR TOUR BOATS
27 FIRE BOATS, PIER 53
28 FERRY TERMINAL
29 HANJIN TERMINAL
30 COAST GUARD BASE
31 INTERMODAL YARD
32 TERMINALS 25-30
33 OLYMPIC TUG & BARGE
34 CROWLEY MARINE

35 TODD SHIPYARD
36 TERMINALS
37 TERMINAL 18
38 GENERAL CONSTRUCTION
39 ASH GROVE CEMENT
40 MANSON YARD
41 J.A. JACK LIMESTONE
42 LAFARGE CEMENT PLANT
43 DUWAMISH SHIPYARD
44 ALASKA MARINE LINES
45 NORTHLAND SERVICES
46 JAMES HARDIE GYPSUM

FIRST AVE. SOUTH BRIDGE

47 DELTA MARINE INDUSTRIES (2 MI. SOUTH)

A shorelines map showing key maritime locations in the Seattle area, 2002. (Courtesy of the artist, Ronald R. Burke)

Five

REACHING FOR THE 21ST CENTURY:

SEATTLE'S WATERFRONT GOES INTERMODAL

Seattle began the long, and often politically difficult, process of redefining itself. The World's Fair of 1962, building the Interstate Highway system (I-5 through the heart of the city), and refurbishing Pioneer Square's old buildings that were built after the Great Seattle Fire of 1889 were among the far-reaching projects. The Port of Seattle entered into a $250 million dollar upgrade of its facilities. Extensive changes were made to Harbor Island and the East and West waterways to accommodate containerized freight. Giant cranes filled the skyline with their lofty towers. Pier 91 became a major unloading facility for Japanese automobiles. A new grain elevator was built just south of Smith Cove at the foot of Queen Anne hill.

As the world's population kept growing, fishing pressures on Atlantic Coast stocks drove more and more European fishing nations to seek product from the Pacific. Factory trawlers, unable to produce in the Atlantic, started fishing off Alaska. New stocks such as King Crab and Black Cod (Sable Fish) encouraged the construction of new vessels. Congress passed the Magnuson Act, limiting fishing within 200 miles of the American Coast to U.S. flag vessels. New fishing vessels of all types were launched throughout Seattle and the Puget Sound area. The Port of Seattle modified its Fisherman's Terminal to accept larger boats and ships. Many of the downtown piers were modified to accept some of the largest factory trawlers.

Small boats, power, and sail proliferated in the post-war economy. The Port of Seattle built the Shilshole Bay Marina at the mouth of the Ship Canal that today hosts over 1600 boats, mostly sail from 14 feet to 70 feet in length. Small boat racing flourished in Lake Washington off Leschi Park and spread to salt water in the middle 1960s. Yachting is a year-round sport in Seattle thanks to the Northwest's mild winter climate; salmon, shell fish, crabs, and shrimp are plentiful and attract many boaters to seek them. Many marinas now dot the shorelines of Puget Sound, Lake Washington, and Lake Union. Pleasure boats grew to outnumber the commercial boats and many marinas were developed to accommodate them. Nearly all yachts and pleasure boats are moored to piers on both the salt and fresh waterways throughout Seattle and Puget Sound. Launching ramps for trailerable boats are located throughout the fresh and salt waterways.

THE ELEUTHERA

(*previous page*) The beautiful 48-foot steel hulled auxiliary ketch *Eleuthera*, owned by Earl Schenck Jr., is seen sailing in Elliott Bay. She was a John G. Alden design and was built in 1951. (Courtesy of the artist Hewitt Jackson)

Mr. Horace W. McCurdy (left), and Mr. Joshua Green (right), attend the dedication and mounting of a historic plaque at a waterfront site on Alaskan Way in Seattle. Beginning in 1952, the establishment of a significant historic plaque was made each year, first by the Yukon Club, commemorating a significant event in Seattle's maritime history. Thereafter for over thirty years, a total of twenty such memorials, first plywood, then bronze plates, were mounted by the Yukon Club and the Propeller Club, also in cooperation with the Puget Sound Maritime Historical Society. (Courtesy of MOHAI Neg. No. shs7012P)

This advertisement shows two floating drydocks at Puget Sound Bridge and Dredging Co., No. 2 Yard across the West Waterway from their No. 1 Yard on Harbor Island. The company built three river steamers for the Alaska Gold Rush, operated a shipyard with six building ways during World War I, fabricated concrete pontoons for the first Lake Washington Floating Bridge, and built a number of wood and steel naval and military auxiliaries in World War II. In 1963, when board chairman H.W. McCurdy retired, the yard became Lockheed Shipbuilding and Construction Co. After an ambitious program of naval construction in 1987, the firm finally succumbed to high labor costs and competition from Gulf Coast shipyards. (Courtesy of Ronald Burke advertisement collection)

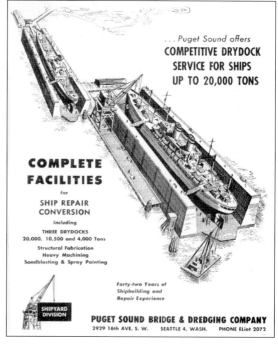

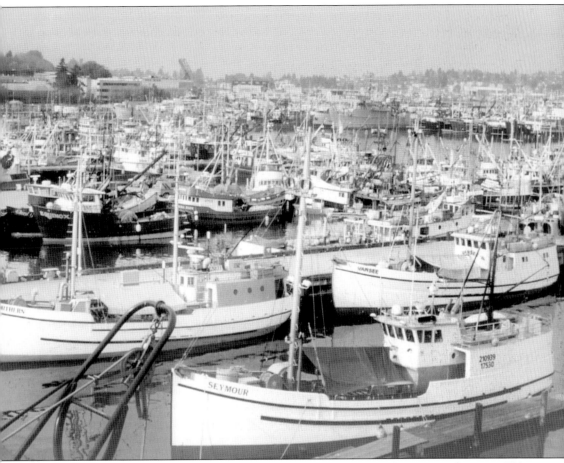

Port of Seattle Fishermen's Terminal now has the capacity to provide moorage for up to 700 vessels. Net storage, staging areas, cranes, and forklifts are available on site. Office and retail space is mostly occupied by fishing-related businesses. A 50-ft. wide, 900-ft. pier has been added to handle large-sized vessels. In addition to modern fishing vessels, this photo shows three surviving members of the venerable halibut schooner fleet: *Northern* of 1927, *Seymour* of 1913, and *Vansee* of 1913. (Photo by Ronald R. Burke)

Philip F. Spaulding was born in Snoqualmie Valley, Washington, and grew up in Seattle. He was graduated from the University of Washington in 1937 with a B.S. Degree in Industrial Engineering. In 1939 he received a Master's Degree, with honors, in Naval Architecture and Marine Engineering from the University of Michigan. Phil began his career with Todd Shipyards in Tacoma, New York, Alameda, and Seattle. In 1952 he founded Philip F. Spaulding & Associates, and the firm became widely known for its designs of ferries (see *Coho* below), cargo ships, tugs, and passenger vessels. Phil and George Nickum founded Nickum & Spaulding & Associates in 1971. Phil was awarded the David Taylor Medal by the Society of Naval Architects and Marine Engineers and he received an award for his inspiring achievements in ship design by the Alumni Society of the University of Michigan. (Courtesy of Phil Spaulding)

One of the most significant vessels to be launched in 1959 was the motor vessel *Coho*, designed by Philip F. Spaulding & Associates. She was built by the Puget Sound Bridge & Dry Dock Co. at Seattle for Black Ball Transport Inc. In her early years *Coho* made nightly departures from Seattle with freight for Port Townsend and Port Angeles. From there she made two crossings per day to Victoria with passengers and automobiles, then back to Seattle for layover before her next return trip to Port Townsend and Victoria. *Coho* is currently used by Black Ball Transport exclusively on the Port Angeles to Victoria run. (Courtesy of Phil Spaulding)

Peter Schmidt served as a naval officer during World War II, obtaining his engineering degree from the University of Washington, and master's degree in Naval Architecture and Marine Engineering from the University of Michigan. In 1953 he founded Marine Construction & Design Co. (MARCO) in Seattle, which became a leader in the construction of modern steel fishing and commercial vessels. Since 1960, MARCO has had a shipyard, fishing and commercial operations in Chile, and a subsidiary, Campbell Industries, in San Diego. Innovations, under Schmidt's leadership, include: the Puretic Power Block, for hauling large fish nets; the Capsul Pump, for pumping fish; and the Eggstractor, for removing roe from salmon. Peter Schmidt has received several awards, including the Seattle Maritime Man of the Year, the Maritime League of Chile, and the University of Michigan Alumni Society Merit Award in Naval Architecture and Marine Engineering. (Courtesy of Peter Schmidt)

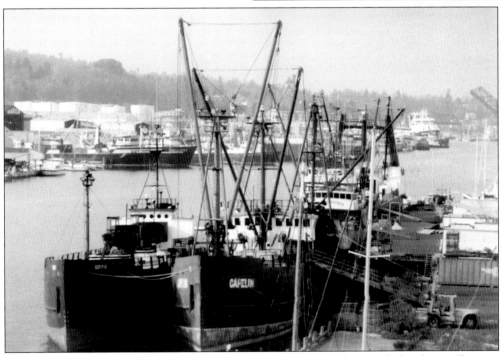

The partial fleet of Western Pioneer Shipping Services pictured here includes the small motor vessels *Capelin*, *Sculpin*, *Aleut Packer*, and *Redfin*. They transport freight to the fishing industry and service 18 ports along the Alaska Peninsula from Craig to Adak. On the return trip they haul frozen seafood to market. (Photo by Ronald R. Burke)

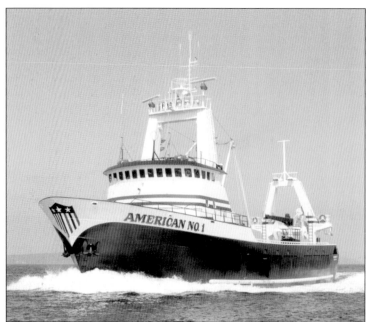

American No. 1 is a 160-foot trawler-processor designed and built by the MARCO yard for fishing in the Bering Sea. MARCO built her hull upside down on the Ballard side of the Ship Canal in 1978, and towed it on a floating dry-dock across to their MARCO yard for finishing. (Courtesy of MARCO Marine of Seattle)

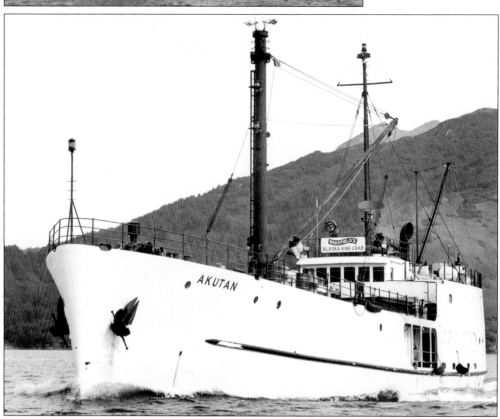

MARCO converted the *Akutan* to a king crab processor in 1963. She was originally a 176-foot twin screw FS Army freight boat. She processed crab for Wakefield Seafoods along the Alaskan Peninsula and Aleutian Islands. (Courtesy of MARCO, of Seattle)

Sabrina is a steel Alaska Limit Seiner designed and built by the MARCO yard in 1982. They are equipped with chilled seawater refrigeration and MARCO hydraulic blocks that allow retrieval of 600 to 700 lb. crab pots from depths of 50 to 60 fathoms. (Courtesy of Marco Marine of Seattle)

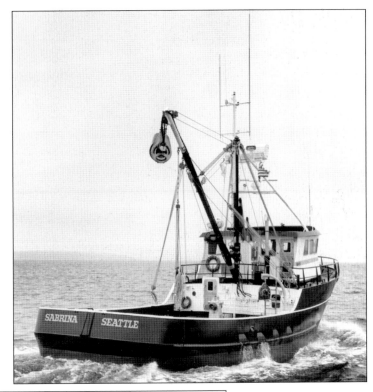

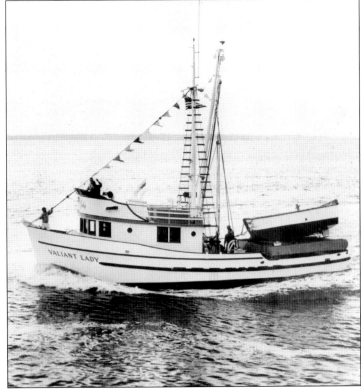

Valiant Lady is a 58-foot steel Alaska Limit Seiner built in 1957. In addition to purse seining for salmon, she also doubles as a dragger for bottom fish in Southeastern Alaska and California. (Courtesy of MARCO, of Seattle)

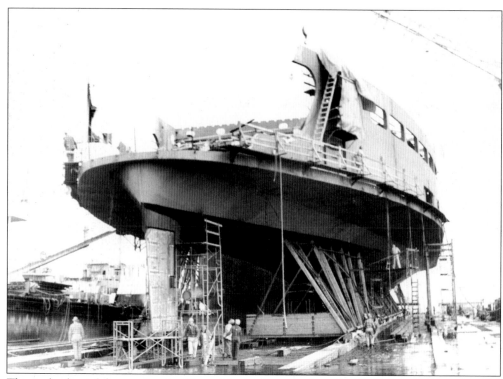

This is the first of the new Jumbo Class of ferries being built at the Todd shipyard in Seattle for the Washington State Ferry System. Shown here is *Spokane* sitting on the launch ways with the hull almost complete and the superstructure in the process of being built. She was launched in April of 1972 during an elaborate ceremony where Spokane tribal queen Carol Sterns christened the new ferry. At the time *Spokane* is said to have been the largest double-ended ferry in the world, with a capacity of 2,000 passengers and 206 vehicles, and a service speed of 20 knots. Innovations on these new ferries included heated observation solariums on the boat deck and elegantly appointed dining rooms. (Courtesy of MOHAI photo collection)

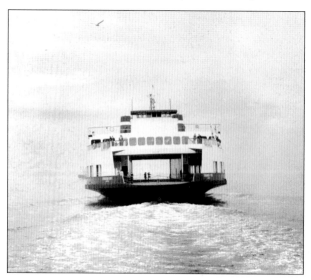

The tradition of inland water-borne commerce lives on in the sturdy vessels of the Washington State Ferry System. Here *Evergreen State* pulls away from Colman Dock some time in the late 1980s. She is rarely, if ever, so empty in these days of rapidly growing population and heavy traffic. (Courtesy of PSMHS, Neg. No. 5324-54)

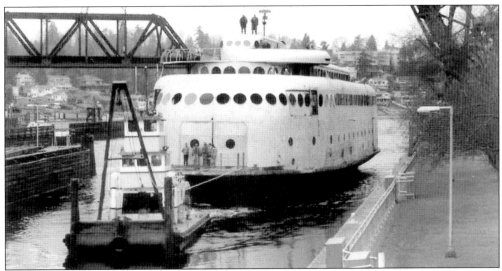

Like many venerable Puget Sound vessels, *Kalakala* disappeared into the Alaska seafood industry. But, unlike the vast majority of such vessels, *Kalakala* returned decades later thanks to the determined efforts of a small group of enthusiasts, who seek to have her restored as a floating museum and meeting place. On March 17, 1999, she was towed from temporary quarters on the Seattle waterfront through the large lock, which she is here seen entering, to longer-term moorage in Lake Union. (Courtesy of George P. Bigley/Deltoid Images©)

Joshua Green, a famous Northwest maritime figure, is holding the certificate from the Puget Sound Maritime Historical Society proclaiming him Commodore of all Puget Sound fleets in 1969. He started his 40-year steamboating career on Puget Sound at age 18, then went ashore and worked as a banker for more than 40 years. On his 100th birthday he stated, "When I make my application to enter the Pearly Gates, I'll be making it as a steamboat man." Mr. Green died five years later at 105 years of age. (Courtesy of, and photo by, Hal Will)

Built in 1952, *Brynn Foss* is featured in this advertisement. Her steel hull and 800-HP Nordberg engine made her the pride of the Foss Tacoma fleet. She also had a fire monitor for assisting at waterfront fires and washing down barges and logs. *Brynn Foss* spent the next 20 years in ship assists alternating with barge and log shifting. In time Foss replaced her with larger, newer boats, and she found employment with line-haul runs to Bellingham, Anacortes, and Port Angeles and towing log rafts to and from Puget Sound and British Columbia ports. She was retired with a worn-out engine in 1978 and eventually sold to new owners in Alaska who painted her orange and re-named her *Bengal Tiger*. (Courtesy of Ronald Burke advertisement collection)

The tractor tug *Arthur Foss* was photographed off Alki Point heading for Tacoma. Her 4000-HP horsepower is applied to twin Cycloidal propulsion units that are mounted vertically, with controllable pitch blades, to provide thrust and steering in all directions. As such, the tractors can exert a thrust of 85 percent astern and 70 percent to either side and are employed in ship assistance. They are frequently positioned at the ship's stern and pulled backwards through the water to provide stopping power as well as lateral thrust for docking. *Arthur Foss* can be found at work in Seattle, Tacoma, and the North Sound. (Courtesy of and photo by Kathy Oman)

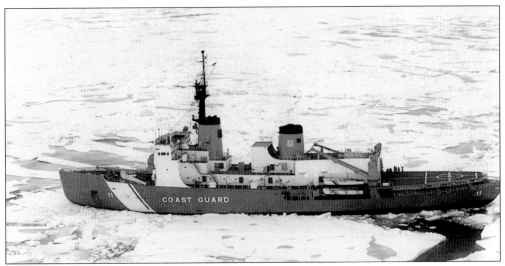

The United States Coast Guard Cutter *Polar Sea*, along with her sister ship, *Polar Star*, both stationed in Seattle, were the largest ships in the U.S. Coast Guard and the world's most powerful non-nuclear icebreakers. During the epic Arctic Ocean Expedition in 1994, *Polar Sea*, along with the Canadian Cutter *Louis S.St. Laurent*, made the first Pacific to Atlantic surface ship crossing of the Arctic Ocean. During this voyage, on August 22, 1994, *Polar Sea*, under the command of Captain Lawson W. Brigham, became America's first surface ship to reach the Geographic North Pole. Earlier in the year *Polar Sea* reached the southernmost location in Antarctica. Thus, it is believed that in 1994, *Polar Sea* became the first ship in history to reach the extreme ends of the global ocean. (Courtesy of Coast Guard Museum Northwest.)

The containership *APL Japan* is shown under the cranes at Port of Seattle, Terminal 5, on July 12, 2002. She had arrived from Hong Kong and would soon depart for Vancouver, B.C., and Yokahama, Japan. She is a C-11 class ship, built in Keil, Germany, and her container capacity is 4905 T.E.U. (20 foot equivalent units). A 69,000-HP Diesel engine pushes her along at a service speed of 25 knots. Her officers are from Singapore or Malaysia with a mixed crew from various third world nations. APL Limited (once American President Lines) is now part of the HOL Group (Nepture Orient Lines) of Singapore. Terminal 5 is managed by Eagle Marine Services, a subsidiary of APL. (Courtesy of, and photo by, Ron Burke)

Delta Marine Industries established their reputation in the commercial fishing vessel industry, having built over 800 commercial vessels since their beginning in 1967. Delta began its move into the yachting market in 1984 by expanding their original family-owned site to create an 18-acre shipyard on the Duwamish River. One of Delta's resplendent yachts is the *Jami*, shown here on Elliott Bay with the Seattle skyline in the background. This luxury yacht *Jami* was launched in 1998 and is 124 feet in length overall. She has a maximum speed of 20 knots and a 2,500 nautical mile range. (Courtesy of Delta Marine Industries, Inc.)

Delta Marine Industries, located near the mouth of the Duwamish river, was founded in 1967 by Jack and Ivor Jones, who still run Delta today. Delta has a reputation for building seaworthy, reliable boats from 1967 to 1992, and has delivered over 800 commercial vessels including seiners, gill netters, pilot boats, and charter boats. Here is one of Delta's famous 58 foot Alaska seiners the *Trisha Michelle*, designed by John Schubert. (Courtesy of Delta Marine Industies, Inc.)

The Alki Point Light Station was established in 1887 when keeper Hans Martin Hanson was hired to maintain a kerosene lantern hung on a post 12 feet above high tide. This was ample light to mark the point before the developing city created its own ambient light. The present octagonal tower supports a round lantern room with a fourth order Fresnel lens made in France. The lighthouse is normally open to the public on weekends. (Courtesy of and photo by Kathy Oman)

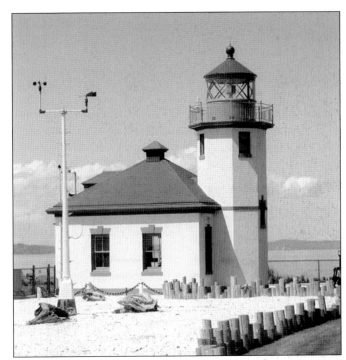

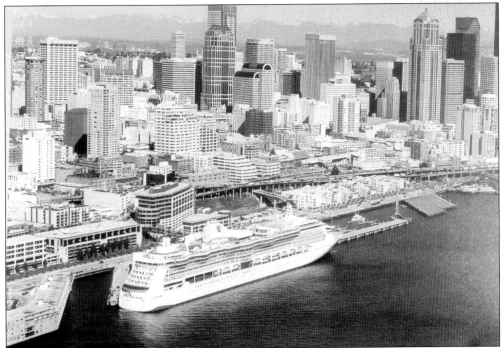

Radiance of the Seas, at 962 feet long, beam 106 feet, and gross tonnage in cubic feet 88,000, can accomodate 2,100 passengers and 900 crew members. She was built at the Meyer-Werft shipyard in Papenburg, Germany, and launched in 2000. She is part of the Royal Caribbean International cruise fleet, and is shown here at the Bell Street Pier 66 Cruise Ship Terminal, with the beautiful Seattle skyline in the background. (Courtesy of Port of Seattle)

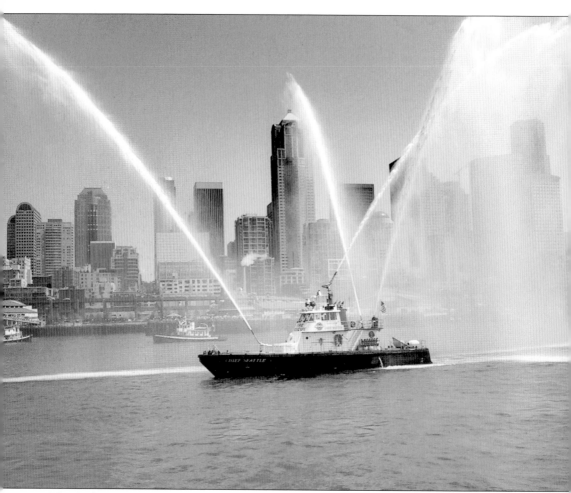

The fireboat *Chief Seattle* sprays her graceful fountains on May 11, 2002, during the Maritime Festival. With her aluminum planing hull and three diesel engines, *Chief Seattle* can race to a fire at 26 knots. On her centerline engine alone, she can cruise at 5 to 6 knots when patrolling the waterfront. Her three rudders, two bow thruster nozzles and two underwater stern nozzles give her great maneuverability in tight places. Paramedics can give aid to trauma victims in a medical treatment room at the aft end of the deckhouse. (Courtesy of, and photo by, Gary White)

Index of Vessels

Index of People